Portobello
–AND THE–
GREAT WAR

Archie Foley & Margaret Munro

AMBERLEY

First published 2013

Amberley Publishing
The Hill, Stroud
Gloucestershire, GL5 4EP

www.amberley-books.com

British Library Cataloguing in Publication Data.
A catalogue record for this book is available from the British Library.

ISBN 978 1 4456 1160 0

Typesetting and Origination by Amberley Publishing.
Printed in Great Britain.

CONTENTS

ACKNOWLEDGEMENTS

We would like to thank the following persons for letting us use their photographs, letters and other memorabilia, and sharing their memories and research: Keith Ahmed; George F. Baird; Catherine Bayes; Doris Bourne; Rhona Brown; Pat Coughlan; Robert Fenley; David Irving; Dorothy Kelly; Gordon Krause; Reynold Krause; Lothian Health Services Archive; Barry McGill; Michael McVeigh; Kitty Marshall; Margeorie Meikie; Bob Robinson; George Linton Rodger; Mary Davidson Smith; Rosalind Surtees and Irene Thomson. We would also like to thank those who allowed us to photograph the rolls of honour and war memorials.

INTRODUCTION

For many, Portobello is just another Edinburgh suburb, albeit one with a mile-long stretch of fine sandy beach – the large signs saying 'Welcome to Portobello, Edinburgh's Seaside' seem to confirm that view. So why should it have a book of its own devoted to its experiences of the First World War? The answer lies in its history. Portobello has not always been part of Edinburgh, and for many years was a burgh in its own right and looked after its own affairs.

Around 1750, the first house was built by George Hamilton on a hitherto desolate stretch of land between Leith and Musselburgh known as the Figgate Whins. He named his house 'Portobello' after the victory by Admiral Vernon over the Spaniards at Puerto Bella in Panama in 1739, and offered refreshments to travellers on the coast road between Edinburgh and Musselburgh. In 1763, William Jamieson, an Edinburgh architect and builder, found extensive clay beds on land that he had feued near to the Figgate Burn, and he very quickly built a brick- and tileworks, followed by a pottery. Other industrialists moved into the area and in addition to brickworks, potteries and clay pits, a paper mill, soap factory and glassworks were founded. Houses for the workforce clustered around these works to create a thriving industrial community in the western part of Portobello. *Scotland Delineated*, published in 1799, describes Portobello as, 'A rising village of about 300 inhabitants employed in the manufacture of bricks, tiles, jars, brown pottery and white stoneware.'

Until near the end of the eighteenth century, the favoured destination of the citizens of Edinburgh for sea bathing had been Leith Sands, but they were losing their appeal due to the growth of industry, particularly a chemical works, in their vicinity. On 11 June 1795, we have the first indication that Portobello was beginning to emerge as a seaside resort when John Cairns advertised in the *Edinburgh Evening News* that he was erecting bathing machines on its beach. Attracted by its mile-long stretch of fine sand, secluded by dunes covered in whins and gorse, seawater (said to be of high quality) and the recently discovered mineral springs, the great and the good of Edinburgh deserted Leith and travelled the extra miles to Portobello. Its distance from Edinburgh meant that only those with carriages, or who could afford the expensive stagecoach fare, made the journey, so Portobello became a Regency Spa from which ordinary folk were effectively excluded.

Around 1800, a new phase of housebuilding began and, starting at Tower Street (now Figgate Street) and Bath Street, made its way eastwards in stages over the next twenty-five years or so towards Joppa. This was to provide accommodation for families wishing to spend the summer months by the sea and also for a growing number of permanent residents. After the end of the Napoleonic Wars, the ranks of the latter were swelled by the families of retired Army and Navy officers. A report on the burgh of Portobello, published in 1833, states that, 'Although it does not contain houses which can be called large or spacious, it has a greater population of respectable and comfortable dwellings than is usually found in a place of its size.' It goes on to comment that Portobello is 'much resorted to by visitors in the bathing season and has also a small permanent society, consisting chiefly of retired families'. William Baird, in his *Annals of Duddingston and Portobello* (1898), makes a similar comment, stating that in the early nineteenth century what Portobello lacked was a middle class, consisting as it did of gentry, retired military and the working classes. Confirmation of the rapid population growth in both the industrial and residential areas is given in the 1821 and 1831 censuses. In 1821, a total of 1,912 individuals lived in 321 houses, but ten years later, the figures had grown to 2,781 individuals living in 517 houses. In 1832, Portobello was grouped with its neighbours, Leith and Musselburgh, to form the Parliamentary Constituency of Leith Burghs. Final acknowledgement that it had come of age, both as an industrial centre and a resort, came when it was one of thirteen new burghs created by an Act of Parliament in August 1833. Baird quotes information produced by the council in 1834, showing that the young burgh was already well provided for in shops, services and employment:

> the resident population engaged in business in the town [consists of] – 'Six grocers, two bakers, three spirits dealers, three butchers, three house agents – two of them being builders and carpenters, one smith, one teacher, one shoemaker, one tinsmith and hardware merchant, one bookseller and stationer, one builder, one painter, one apothecary, and four medical men.' Besides these there were 'one extensive glasswork, two potteries, three brickworks, one soapwork, and one mustard manufactory, the labouring population attached to which was not less than 500 to 600.'

There were initial accommodation and financial problems to be overcome, but the councillors and officials who looked after Portobello's affairs during its period of independence did an excellent job. Over the years, amenities and facilities for its ever expanding population were introduced and improved; gas street lighting first appeared in 1835 using a supply from Musselburgh and was later expanded and extended to domestic users from a gasworks in the town. Portobello had suffered badly during the cholera epidemic of the late 1830s, and installing a piped supply of clean water, allied to a fully functioning drainage and sewage system, was one of the council's major achievements. Residents could feel secure not only by having well-lit streets, but also by knowing that the burgh constabulary was patrolling them and that swift justice would be handed out in the local magistrates' court.

The advent first of the railway, in the 1840s, and then the cable tramway to and from Edinburgh, in the 1870s, made travel much more affordable for the working

classes, who flocked to the seaside in increasing numbers. Portobello became Scotland's premier resort, and the thousands of visitors contributed hugely to a local economy already firmly based on industry and commerce. After years of legal wrangling and renting unsatisfactory accommodation, the Burgh Council decided to build its own municipal chambers with space to house the whole staff and machinery of municipal government, and a site was bought on the north side of the High Street at the junction with Ramsay Lane. Work began in December 1877 and the new premises were ready for occupation in autumn 1878. The magnificent building, designed in exuberant Scottish Baronial style, still does duty today as the local police station.

By the last decade of the nineteenth century, Portobello had shown that it was well capable of conducting its own affairs. It had facilities and amenities equal to those of any burgh of similar size in Scotland, and a wide assortment of clubs and other organisations that catered for most needs and interests. Portobello folk looked after themselves and saw no reason why this should not continue. However, Edinburgh was keen to extend its boundaries and, in September 1894, sent a letter to the Burgh Council proposing discussions on terms for amalgamation. This was not treated as a serious proposal and, according to William Baird, 'Portobello officials were not really disturbing themselves much about Edinburgh's arrangements and so far as we can learn had not even replied to their first overtures.' Even after a second communication, with more details of terms and proposals, was received a year later in October 1895, he says,

> the question of amalgamation was not a 'burning' one and was not seriously considered as within the range of practical politics. Indeed the general feeling within the townspeople seemed to be that as the town had got on very well under its own local management for so many years it was difficult to see what great advantage was to be gained by its absorption into Edinburgh. The loss of its individuality and municipal importance was indeed held by many to be a great sacrifice to make for any supposed advantage that could be offered.

How to deal with Edinburgh's approach split Portobello Council down the middle. There were those who called for outright rejection, and an equal number who favoured keeping negotiations going to see what terms Edinburgh could be persuaded to concede in order to get what it wanted. This strategy was finally approved, but only on the casting vote of the provost. Outside the council chamber, the townsfolk were equally divided; a plebiscite of the ratepayers on what action should be taken resulted in an equal number of votes being cast for and against amalgamation.

Negotiations continued and, in April 1896, agreement was reached on terms extremely favourable to Portobello. All the promises by Edinburgh Council, including building an assembly hall capable of seating 800 people, providing public baths and the creation of a public park of not less than 40 acres, were enshrined in the Act of Parliament extending Edinburgh's boundaries, which received Royal Assent on 7 August 1896. On 1 November, Portobello Burgh Council ceased to exist and its elected members moved from High Street, Portobello, to the High Street in Edinburgh.

However, life continued very much as before for the residents of the formerly independent burgh; their day-to-day existence did not depend on anything that could only be obtained from Edinburgh. They could still shop along the High Street for food, household necessities and clothing; banking and financial help and advice could be had from branches of the major Scottish banks and, as mentioned earlier, there was an abundance of social and leisure activities. Meaningful independence still existed where it mattered, at local level. William Baird used a local comparison to make this prediction in 1898:

> Joppa … was quite detached and separate from Portobello and was always spoken of as apart from its greater neighbour. But its absorption into the burgh during the last thirty years has not obliterated its name or individuality any more than the good name of Portobello is likely to be lost in that of the City of Edinburgh.

Portobello's sense of separateness was not only influenced by its geographical distance from Edinburgh, but also by its physical detachment. Looking from King's Road, on Portobello's western edge, towards the eastern extremity of Edinburgh at Jock's Lodge, one would have seen an area of rich farmland with only a few dwellings among the fields. Indeed, this remained so until the rash of bungalow development in the 1930s. Despite rail and tramway connections, it was not a journey that the townsfolk made without having a good reason, such as going to work, so contact with the city was slight. Edinburgh's Lord Provost, J. Lorne McLeod, hit the nail on the head when, addressing a patriotic meeting in Portobello Town Hall in March 1917, he said, 'Geographically, Portobello is still retaining much of its individuality, and that feature makes it almost impressively aloof from the city in many respects.' That aloofness and consciousness of its history meant that Portobello's response to the trials of war would be very much that of a community.

CHAPTER 1

IN THE BEGINNING

The First World War was the consequence of the assassination of Archduke Franz Ferdinand of Austria-Hungary and his wife by Bosnian Serbs in Sarajevo on 28 June 1914. Austria, backed by Germany, threatened Serbia, who in turn had sought and secured the support of Russia. This placed Germany in a potentially dangerous situation because any conflict would not be confined to the Balkans. France and Russia were bound by treaty to come to each other's aid in the event of attack, so Germany could face war on two fronts. Austria-Hungary declared war on Serbia on 28 July, provoking Russia to mobilise its Army. On 1 August, Germany declared war on Russia and two days later on France. Britain was not obligated by any treaties or events up until then to go to war, but declared war on Germany on 4 August 1914, after the Kaiser's troops flooded into Belgium in accordance with a long-prepared plan to invade and quickly defeat France by outflanking the French Army defending the Maginot Line. Both Britain and Germany, as successor to the Kingdom of Prussia, were parties to the 1839 Treaty of Paris, by which the Great Powers of Europe had guaranteed the independence of the recently created Kingdom of Belgium. The German Chancellor had ignored British warnings that it would honour its treaty obligations to defend Belgium should Germany violate its neutrality, and famously wondered why Britain would enter into a major conflict because of what was said in a 'scrap of paper' from so long ago.

Shortly after the outbreak of war, on 9 September 1914, William Floeder, a fifty-year-old German, who said he was a marine fireman, lodging in Leith, appeared in Portobello Police Court and pleaded not guilty to begging from two ladies in Portobello. It was said that he had gone to a house and told the women, and afterwards the police, that he had been discharged from the local bottlemaking works because of his nationality, which was shown to be untrue. The magistrate asked him why he had not returned to Germany when war broke out. Floeder replied that he had nothing to do with the Army or the war, but later said that he had tried and failed to get out of the country. The magistrate admonished him and recommended his removal to Redford detention camp. Floeder was accordingly handed over to the military authorities and taken to Redford.

If there was one part of Edinburgh where Floeder's story of having been employed in a local factory might have been believed, it was Portobello. Around 1880, Thomas Wood, owner of Wood's Bottleworks in Baileyfield Road, realised that in order

to remain competitive he would have to discard the old machinery and methods of working at Portobello and adopt a modern European-style manufacturing system. To ensure that he got as good a return as possible from his investment, Wood imported skilled workmen from Germany and Sweden. Richard Cooper & Company, the other bottleworks in Portobello, followed the same path as Wood's, and a sizeable number of skilled workers, mostly German, came to find work in the Portobello factories during the remainder of the century.

Some of the immigrants brought families with them, but others married Scottish girls and their children were born here. Crucially, very few, if any, would have taken out British naturalisation papers, and the outbreak of war brought disruption and heartbreak, whatever their circumstances. By the end of October 1914, acting on instructions from the Scottish Office, Edinburgh's chief constable had arrested all Germans, Austrians and Hungarians of military age (between seventeen and forty-five years) living in Edinburgh and had taken powers under another section of the Aliens Restriction Order of 1914 to expel all Germans aged over forty-five from Edinburgh, which was a Prohibited Area. It was reported in *The Scotsman* on 24 October:

> A dozen alien enemies of military age were removed from Portobello last night. It was the evening for reporting to the police, and those of the proper age were invited to remain. They were afterwards taken to Edinburgh in a police waggon [*sic*].

Presumably, it was an invitation they felt unable to refuse. This dozen had probably escaped earlier arrest and detention because they were classified as skilled workmen upon whom the jobs of Scottish workers depended, but now there were no exemptions. The total number of 'alien enemy' bottle workers would have been much higher than this but, unfortunately, this is an area of local history where there has been very little research and our knowledge of these families is very limited.

One family about whom we do know something was that of Karl Heinrich Mutzke and his wife Agnes, who arrived in Portobello around 1900 to live in a flat at No. 16 Viewforth Buildings, Fishwives Causeway, opposite Wood's Bottleworks, and for this we have to thank the research of their great-grandson, Robert Fenley. Karl Heinrich was born in Dresden and Agnes came from Poland, but they had married in Neusettl in Bohemia (now Nove Sedlo in the Czech Republic). They brought six children with them: Karl Heinrich, Oswald Franz (Robert Fenley's grandfather), Marie, Paul Oskar, Martha and Willi Emil. He died in February 1901 in Fishwives Causeway, a month after the birth there of Karl and Agnes's last child, Emma Elizabeth.

Oswald Franz married Sarah Flynn in June 1904, and they had three children born at No. 24 King's Road, Portobello. Karl Heinrich Jnr met Louisa Richter, from what is now the Czech Republic, when she came to visit relatives in Scotland, and they married in June 1905. A daughter and four sons were born in Scotland: Louisa, Willi Paul, Karl Heinrich, Oswald Franz and Richard Robert. Paul Oskar married Margaret Smith in June 1908, and they had three children, all born at No. 10 King's Road.

All three brothers were interned on the Isle of Man during the war, but their father was not. Karl Heinrich Snr died at the home of one of his daughters in Glasgow in

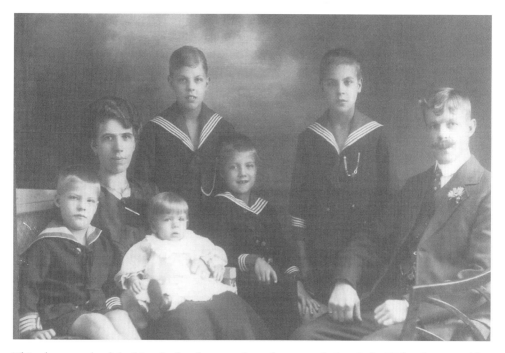

This photograph of the Mutzke family was taken after repatriation. Baby Walter has joined his four brothers, who were born in Scotland.

January 1917, after perhaps having been forced to leave Edinburgh because it was a Prohibited Area. Although there is some confusion with dates and names in official documents, the brothers had been reunited with their families by the end of 1919.

Karl Heinrich Jnr was repatriated to Dresden by the authorities, and although the records say 16 November 1919, the true date was probably much earlier, as Louisa's fifth son, Walter Heinz, is registered as having been born there on 21 November 1919. Robert Fenley made contact with Richard and his German-born brother Walter, and was given an insight into the difficult times during and immediately following the First World War. Richard, in particular, remembered hearing from his older brothers about trouble when they went to Towerbank School in Portobello. Sometimes the police had to be called to smooth things over. There, they were shouted at as 'German pigs', but when they moved to Dresden this changed to 'British pigs'!

The other brothers and their families, with one exception, left Portobello after being released from internment. Paul Oskar's daughter, Agnes Martha, known as Nancy, remained and died in November 1943, still living in King's Road.

At the end of December 1906, *The Scotsman* newspaper, in a review of the year's commercial activity in Edinburgh, remarked,

> one of the most satisfying features of enterprise is the erection of a new chocolate factory in Portobello near to King's Road, and abutting the North British Railway line to Leith, which when completed will give employment to several hands.

Permission to build the factory had been granted twelve months previously to Charles William Schulze, originally from Brunswick in Germany, but for many years a prosperous cloth merchant in Galashiels.

He wanted to establish a business making luxury chocolate products in the Belgian or German style, which would not only be a first for Portobello, but also for Scotland. He was equally radical and innovative in the design of his factory. Situated on the western edge of Portobello, at the start of the main road to Edinburgh, the building is four storeys high, about 160 feet long and 55 feet wide, with exterior walls of red pressed firebrick. However, it is what is behind the walls that astonished local residents as they watched the construction proceed. Schulze decided to have his factory built on reinforced concrete foundations with floors and roof of the same material, supported on reinforced iron pillars and beams. People remarked on the extreme depth of the foundations, the thickness of the floors and flat roof, and the strength of the reinforced iron pillars and beams. All of this was said to be necessary because of the clay sub-soil and the need to bear the weight of heavy machinery.

The money for the construction of the factory and the purchase and installation of machinery was provided by Schulze Snr, who leased the building and fittings to the Continental Chocolate Company, which was essentially a partnership formed by his sons, Charles Frederick Schulze, Hugh Lees Schulze and William Rudolph Schulze, all of whom had been born in Britain. Charles and Hugh came to live in Portobello at No. 19 Abercorn Terrace, but Rudolph seems to have remained in Galashiels. Delays with machinery and the need to train staff meant that full production did not get underway until 1911, but only after a number of skilled workers had been imported from Germany. However, any hopes the Schulzes may have entertained that the company was now set for a prosperous future were dashed by the outbreak of the First World War only three years later.

Portobello was not immune to the wave of anti-German hostility that engulfed Britain, with its attendant paranoia concerning spies and secret agents, especially after the fall of Antwerp. Almost inevitably, attention focused on the Continental Chocolate Company and its large, extremely strongly built premises, located at an important road junction, and next to two railway lines. A sort of hysteria gripped the community. It was well known that the owners were German, and soon it was alleged that the specially strengthened floors were really to bear the weight of heavy guns that could threaten Leith Docks and perhaps Rosyth Naval Base. It was pointed out that the large concrete loading bank could quite easily provide parking for over a dozen military lorries. Questions were also being asked about the German workers. Did they also have a more sinister role as spies?

As the speculation grew ever wilder, the civil authority decided to act and Edinburgh City Police entered the factory on 16 October 1914, carrying out a thorough inspection lasting several hours. On 19 October, *The Scotsman* reported, 'Nothing of a compromising character was found. The military authorities are also engaged in an inquiry as to the remarkably solid character of the concrete foundations and the great strength of the building.' The following day it was reported that 'the military authorities have come to the conclusion that there is no occasion for them to take action

concerning this building.' Although some employees had been removed and taken to Edinburgh by the police as being enemy aliens of military age, the decision must have brought some relief to the Schulzes, but this proved to be short-lived. The military did take over the building under the Defence of the Realm Act as accommodation for troops, and on 30 October 1914, it was occupied by a detachment of Royal Engineers who had been living locally under canvas. This apparent change of mind was probably prompted by the revelation that the building's owner, Charles William Schulze, was not, as everyone assumed, a naturalised British subject. Despite having lived in this country for around fifty years, he did not apply for British citizenship until after the outbreak of war in August, only to be told by the Home Office that he was too late as it was no longer granting naturalisation papers to Germans. The consequence was that Mr Schulze remained a German national and had to register with the police in Galashiels as an enemy alien. The military felt that it was not in the public interest for such a strong building in an important strategic position to be in 'enemy hands' and took it into their control, where it remained until the end of the war, providing quarters for thousands of troops.

Tragically, the First World War brought more than financial loss to Charles William Schulze. One son, William Rudolph, serving as Private in the Cameron Highlanders, was killed in action on 18 July 1916, and another, Hugh Lees Schulze, a Lieutenant in the Dorset Regiment, was killed on 29 October 1918.

All sections of the local population swung into action to help the war effort. On four evenings, the military band of the 25th Edinburgh (Portobello) Company Boys' Brigade paraded through the streets of the town to collect money for the Scottish National Relief Fund. This was a band made up of older company members and its ranks were already depleted as four players had been called up with the Territorial Army. The selections played included 'Rule Britannia', the Russian National Anthem and 'La Marseillaise', and parades always ended at the top of Bath Street with the playing of 'God Save the King' and hearty cheering. The spectators in the streets were not slow to hand over their money to the Boys' Brigade collectors who accompanied the band and £43, equivalent to almost £2,800 today, was collected over the four evenings. This was made up of 5,710 coins, including one half-sovereign, eighteen half-crowns, twenty-two two-shilling pieces, 160 shillings, 352 sixpences, 280 three-penny pieces, 4,197 pennies, 679 halfpennies and two farthings. In addition, there was a £1 note, an American 25 cent piece, a low denomination German coin and the inevitable button.

By the third week in August, about 7,000 Edinburgh and Leith Territorial soldiers had been mobilised and more were expected. There were proposals in the newspapers that efforts should be made to supply all these men with socks and, in response, a central committee was formed in the city to make this happen. It aimed to provide socks to every man for the duration of the war, so a huge effort would be required to promote the project, raise money to buy wool, recruit knitters and collect finished work. Edinburgh and Leith were divided into districts under the direction of local ladies and it was made known that in Portobello Mrs Howieson, No. 9 Stanley Street; Mrs J. Campbell, Belleville, Argyle Crescent; Mrs Cuthbertson, Maitland Lodge, Duddingston; Mrs Lee, The Neuk, John Street; Mrs Grieve, Coillesdene, Joppa and

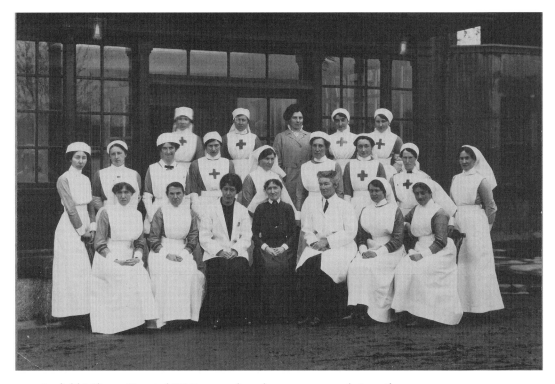

Seafield Military Hospital. VAD nurses have large crosses on their uniforms.

Mrs Brodie, Royal Bank House, would give information and receive work, materials and donations. In addition to this, members of the Portobello Branch of the Scottish Women's Co-operative Guild had already begun knitting socks for the Territorial Army and the Portobello Co-operative Society had given them a grant to augment money taken out of their funds to buy wool.

In 1909, the War Office decided that the British Red Cross should be given the role of providing supplementary aid to the Territorial Forces Medical Service if war broke out. In order to provide trained personnel for this task, regional branches of the Red Cross organised units called voluntary aid detachments. All voluntary aid detachment members (who themselves came to be known simply as VADs) were trained in first aid and nursing. Within twelve months of the scheme's launch, they numbered well over 6,000 and membership grew to 74,000 on the outbreak of war in 1914 in over 2,500 detachments nationwide. Two-thirds of these were women and girls. During the war, in addition to the nursing members, VADs were employed as cooks, kitchenmaids, clerks, housemaids, wardmaids, laundresses and drivers. A much appreciated letter-writing service was provided by women for troops in hospital in France who were not able to write their own letters, either because they were too sick or were illiterate.

This poem, written by a Portobello VAD, appeared in the *Portobello Advertiser* on 21 August 1914, and it is difficult to imagine a poem expressing such sentiments being published, or perhaps even written, today. It tells us a great deal about how the war

that had just begun was seen as a fight for freedom and honour, a struggle between good and evil, and is an appeal to men and women alike to come forward to serve their country. The writer, who is probably female, considers women's contribution to the war effort to be just as vital as that of men, but continues to see them in their traditional roles of tending the sick and wounded, home making and looking after children. In that, too, she is expressing the contemporary attitude, but it was a view that would change over the coming years.

AN APPEAL

Composed by a member of the Portobello
Voluntary Aid Detachment

The Lion's on the warpath,
The country's now awake;
We're fighting for our freedom,
Our honour is at stake.

Let every man who's able
Leave pen and shop and plough,
And help defend his country,
For all are wanted now.

The women too are needed,
Wherever blood is shed;
There's poverty to cope with,
And children to be fed.

Don't waste the precious moments,
There's no time for delay;
Your King and country want you,
So start and help today.

The Portobello detachment had organised daily sewing groups in Towerbank School to make clothes for sick and wounded servicemen and their dependents, and was appealing for donations of money, goods or any kind of clothes. These could be handed to the detachment's Assistant Commandant, Mrs Dunn, No. 15 Durham Road, or its Quartermaster, Mrs Robertson, No. 23 Lee Crescent. Mrs Dunn was the wife of the Commanding Officer of the 4th Battalion Royal Scots, Lieutenant-Colonel R. S. Dunn and Mrs Robertson of the then Captain William Robertson VC.

Reports in the local and Edinburgh newspapers show that fundraising and welfare activities by organisations and individuals in Portobello were numerous and varied. The following examples were recorded during the first six months of the conflict, but the efforts did not flag during the entire course of the war.

Shortly after war was declared, a lady advertised that she was willing to offer space in her house to allow six beds to be installed for the treatment of sick and wounded soldiers brought to the Edinburgh district. Monsieur Tegg in Portobello announced that he would gladly give free lessons in the French language to any nurses preparing to go to the front, and Mr James Veitch donated one ton of potatoes to the war effort.

In a fundraising effort for the Red Cross, local businessmen Adam Grieve, John Forsyth and W. A. Gray all donated £5. Richard Cooper & Co., the bottle manufacturers, gave £50 to the National Relief Fund, which also benefited by smaller donations from Mr Thomas Miller, Mrs Dickie, Mr Robert Merrie, Mr John Ferguson and Mr J. A. Gray. Portobello Ladies Golf Club took one third of its accumulated funds to provide blankets for troops, while the workers at the potteries collected £5 and the members of Portobello Amateur Rowing Club £2 for the Relief Fund.

Edinburgh finally fulfilled all the pledges it had made in 1896 to secure amalgamation with Portobello when the promised assembly hall was opened by Lord Provost Inches, accompanied by the city magistrates and councillors, in the afternoon of 30 October 1914. In his speech declaring the hall open, the Lord Provost stressed that amalgamation had benefited both parties and assured the audience that although the last of the stipulations had been met, this did not mean that Portobello had received all it was to get. In the evening, the hall, now officially called Portobello Town Hall, staged its first event, a concert under the patronage of the Lord Provost in aid of the Scottish National and Belgian Relief Funds. The plight of the thousands of refugees displaced from German-occupied Belgium struck an emotional chord with the British population, and over 250,000 were given refuge in Britain, with 2,000 finding a safe haven in Scotland. Some must have come to Portobello, but we only know this because of a newspaper reference to Belgian boys applying to enrol at the secondary school for the autumn term in 1914 and being told by the Higher Education Committee that they were not entitled to free education. Given their circumstances, this seemed extraordinarily harsh, and after an appeal, common sense prevailed over the rule book and the decision was overturned.

Portobello made a useful contribution to Edinburgh's Scottish National Flag Day, held on the last Saturday of November to raise money to provide comforts for the Scottish regiments at the front. Despite it being a cold, windy day with intermittent heavy showers of rain, around fifty collectors, mostly girls with some boys, took to the streets to persuade the public to part with a few coins in exchange for having a little paper flag pinned to their clothing. There was a choice of two flags, and the Scottish Royal Standard, a red lion rampant on a gold background, had the edge over the St Andrew's Cross in terms of popularity. Portobello Celtic Band paraded through the streets at intervals during the day and also collected a fairly substantial amount. Portobello had been divided into two districts, with Mrs Peters of Brunstane Road in charge of the west and Mrs Grieve, Coillesdene, Joppa, organising the east, and at the end of a very arduous day Mrs Grieve entertained all concerned with tea at her house. When all the money was added up, Portobello had gathered just over £50 towards the £1,500 sum for the whole of Edinburgh.

In December, the pupils of Portobello Secondary School sent a Christmas Box to the value of just over £6 to the troops and Portobello Rotary Club held a special concert

in the Gaiety Theatre, Leith, for the children of the servicemen. This was attended by the Lord Provost of Edinburgh, who began a speech to the children by wishing them a happy New Year and then wondered if '[they] might think that curious when their fathers and brothers were engaged in one of the most awful wars that had ever been thrust upon the country and were fighting at the front for their country'. He then went on to say,

> It might have been worse, as was seen from the position not only of the French and Belgian children, but of the French and Belgians generally. Their sad fate was a great deal worse and he had no doubt they would extend their sympathy to them and wish for a speedy ending of the war.

The Lord Provost's words were no doubt well-intentioned, but perhaps this was not the most appropriate occasion on which to remind children of their own sorrows and the sufferings of others elsewhere.

On 23 December, a concert was organised by Portobello Annual Club in the Town Hall to raise money to send a New Year's gift to every serving soldier and sailor from Portobello. The chairman for the evening was club president William Bryce, who announced that more than 750 Portobello men were now serving in the forces. The large audience was first addressed by Colonel Sir Robert Cranston, the former Lord Provost of Edinburgh and a long-serving member of the Edinburgh Volunteers, who had recently raised the 15th (1st City of Edinburgh) Battalion Royal Scots. He took the opportunity to appeal for recruits, saying 'it was the bounden duty of every man who was free to join' and declared, perhaps to the surprise of the audience, that the working classes were not doing their duty. However, this piece of what he called 'plain speaking' was very quickly qualified:

> He did not refer to Scotland. He was proud to see the part which Scotland had played. He referred to England, and particularly to Yorkshire and Lancashire … the life of every free young man was not his own but belonged to the country, and he should not hesitate if need be to give his life for his country. (Applause)

The speech of the Member of Parliament for Leith Burghs, G. W. Currie, was also punctuated by applause when he spoke of those who had been killed or wounded, and mentioned that three families in Portobello had sent five sons to the war and another had given four.

Despite the presence in the cast of Scotland's 'Strathspey King', the famous Scots fiddler and prolific composer, James Scott Skinner, the concert itself was given less than half a dozen lines in the newspaper report. It did say, however, that the audience was treated to 'an excellent programme' by the singers and instrumentalists.

On Christmas Day, the 5th Battalion Royal Scots at the Marine Gardens enjoyed a special Christmas dinner. This was followed by a film show provided by the officers for the wives and families of the soldiers and the giving out of gifts at a Christmas tree. The detachment from the 7th Royal Scots billeted at the former Chocolate Factory on

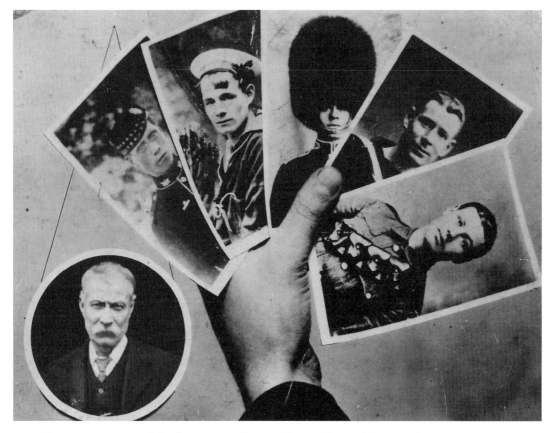

Thomas Patterson and his five sons. William and Samuel joined the Royal Navy, Robert and Joseph joined the Royal Scots and Joseph joined the Scots Guards.

Portobello Road was not forgotten, and the men marched out to join the rest of their comrades for a visit to the Gaiety Theatre in Leith.

It is only in comparatively recent years that Christmas has become a general holiday in Scotland, and for most folk in Portobello, Christmas Day 1914 would have been an ordinary working day. However, since the passing of the Half Holiday Act, shopkeepers had taken to closing their shops on Christmas Day and by about lunchtime the streets were said to have taken on 'an almost Sunday like appearance', with people taking advantage of an unaccustomed holiday to come out for a stroll in the winter sun. Undeterred by the German Navy's bombardment of the English seaside resorts of Hartlepool, Scarborough and Whitby less than two weeks previously, most made their way to the Promenade to look out over the Firth of Forth. What they saw would have been both impressive and reassuring:

Lying clearly and majestically in the centre of the Forth was that huge rock [the island of Inchkeith], upon which during the day a very enjoyable Christmas entertainment to the troops took place, while dotted round were innumerable cruisers and the

occasional battleship. They seemed to be all asleep, lazily rocking on the moving tide but one could feel content that only a wisp of smoke on the horizon would suffice to bring everything in a moment's notice into a mass of alert and ever-ready figures.

This concentration of capital ships could not be termed a brooding presence, but it was a constant reminder to the locals that their country was at war. The early optimism had evaporated, and people now accepted that the fighting could continue for years as they saw more and more of Portobello's young men going off to the Army and Navy.

At the outbreak of the war, the British Regular Army, although well-trained, was a very small force consisting of 247,432 regular troops. In contrast, Britain's ally France had 1.3 million regular troops in the field and Germany 1.75 million. The Army was organised to defend Britain's imperial interests and almost half of the Regular Army regiments were stationed overseas in garrisons throughout the British Empire. Each infantry regiment had two regular battalions, one of which served at home and provided reinforcements to the other, which was stationed overseas. In August 1914, 1st Battalion Royal Scots was in Allahabad, India, and the 2nd Battalion was stationed in the South of England at Plymouth. The Regular Army was supported by the Territorial Force, and in the case of the Royal Scots this support was provided at the outset by

1/4th Battalion (Queen's Edinburgh Rifles)
1/5th Battalion (Queen's Edinburgh Rifles)
1/6th Battalion, Edinburgh
1/7th Battalion, Leith
1/8th Battalion, Midlothian; East Lothian and Peebles-shire
1/9th (Highlanders) Battalion, 'Dandy Ninth', Edinburgh
1/10th (Cyclist) Battalion, West Lothian

These battalions, in common with their counterparts all over Britain, had been mobilised for service overseas, but even with the addition of other reservists the Army was in no position to make a major contribution to a land war in Europe. This had been put very forcibly to the government by the newly appointed Secretary of State for War, Lord Kitchener, who forecast that the war would last three to four years and asked for 1 million recruits to the Army. Kitchener had never made a secret of his contempt for the Territorial Forces and referred to them as 'weekend warriors'. He saw no positive role for them in the war. His new army would be made up of patriotic volunteers, who would be absorbed into the existing regiments of a vastly expanded Regular Army. While there were many who did not share his opinion on the territorials, there was a huge majority in favour of a volunteer army.

On 7 August 1914, Kitchener made his first appeal for 100,000 volunteers with his pointing finger photograph at the forefront of a massive publicity campaign and the target was met within a month. In Edinburgh, a Regular Army recruiting office was opened in a former shop in Cockburn Street under the command of Recruiting Staff Officer, Captain William Robertson VC of Lee Crescent. William Robertson joined

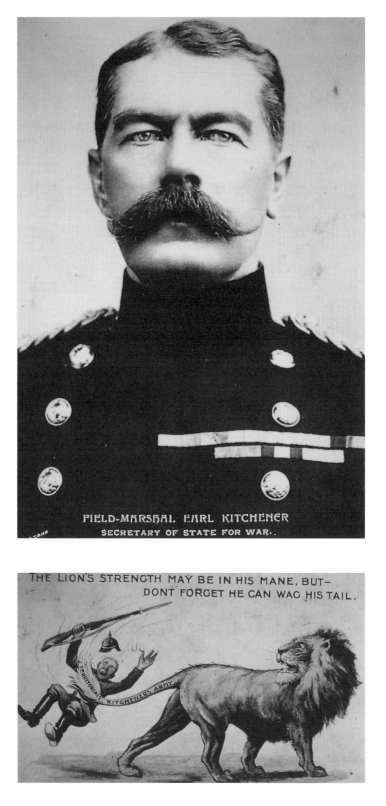

FIELD-MARSHAL EARL KITCHENER
SECRETARY OF STATE FOR WAR.

THE LION'S STRENGTH MAY BE IN HIS MANE, BUT—
DONT FORGET HE CAN WAG HIS TAIL.

the Gordon Highlanders at the age of nineteen and served in India for a number of years until his regiment was sent to South Africa in 1899. He won his Victoria Cross in operations during the defence of Ladysmith in October of that year and the award was gazetted on 20 July 1900:

> William Robertson, Sargeant-Major (now Quartermaster and Honorary Lieutenant), The Gordon Highlanders, Date of Act of Bravery: 21st October, 1899. At the Battle of Elandslaagte, on the 21st October, 1899, during the final advance on the enemy position, this Warrant Officer led each successive rush, exposing himself fearlessly to the enemy's artillery and rifle fire to encourage the men. After the main position had been captured, he led a small party to seize the Boer Camp. Though exposed to a deadly cross-fire from the enemy's rifles he gallantly held the position captured, and continued to encourage the men until he was wounded in two places.

When war was declared, he rejoined the Army, but at almost fifty years of age could not be considered for front-line service and was given the post in Cockburn Street. Despite being almost overwhelmed by the flood of recruits at the outset and the continuing demands of his job, he was also very active in Portobello's war effort. The columns of the local paper show that he was a frequent speaker at recruiting and other meetings, and a regular attender at charity and welfare events of all kinds. He was subsequently promoted to the rank of Lieutenant-Colonel and also received the OBE in 1917.

This was how most Britons viewed the Kaiser.

On 1 September, Portobello held what was reputedly its largest outdoor gathering, when over 2,000 people turned out for a recruiting meeting in Livingstone Place to inaugurate the opening of a special local recruiting office in the Police Court Room. The principal speaker was G. W. Currie MP, who began by leading the audience in a rendition of *Rule Britannia*, assisted by the band that had been entertaining the crowd. His motion that this meeting of Portobello citizens should pledge unswerving support to the government in its prosecution of the war was carried unanimously, as was one by Councillor Thomas Adams on the need for any lawful means to be used to gain recruits for Lord Kitchener's Army. The crowd also responded with enthusiasm when he said that he hoped that the German Emperor would in due course be sent to St Helena or Devil's Island. When the meeting ended, several young men were inspired to march the short distance to the recruiting office to enlist. In its first week of operation, eighty recruits were passed as medically fit and completed attestation for the Army. There had been an earlier special recruiting station in Portobello, for the Lord Provost-inspired 15th (1st City of Edinburgh) Battalion of the Royal Scots. On 1 October, it was announced that recruiting was going well and the establishment should be up to strength within a week. Posters asking for the final 200 men still required to come forward were posted up around the city and Sir Robert Cranston, the battalion's Commanding Officer, was given permission to open temporary recruiting offices at twelve locations, one of which was in Portobello, where someone would be on hand to take names and complete the attestation forms. Every man who joined was promised a pair of boots and a shirt that would be made by out of work local seamstresses. The target was reached, although about 550 of the battalion's total strength were actually recruited in Manchester.

Portobello was a popular destination for recruiters from Edinburgh, perhaps because of the capacity and facilities of the new Town Hall. A former City Treasurer and Liberal Member of Parliament for the Edinburgh East constituency, Sir George McCrae, was the next person to announce that he was raising a new Edinburgh battalion to serve with the Royal Scots. McCrae, who, like Sir Robert Cranston, had been a senior officer in the Edinburgh Volunteers, was a charismatic, popular personality in Edinburgh and was received with hearty cheering by the audience of over 300 in the Town Hall when he came to appeal for recruits for his battalion. He said he wanted men for two reasons. First, he wanted large reinforcements for the purpose of giving some rest to those who had been fighting the long weary battle. The second reason why he wanted a very large number of fresh men was that there should be a sufficient force at the right place at the right time. McCrae's Battalion followed that of Sir Robert Cranston as the 16th (2nd City of Edinburgh) Battalion and was notable for the large number of footballers and other sportsmen among its recruits. The most noteworthy contribution, and the one that is best remembered, came from Heart of Midlothian FC, whose first team volunteered en masse. Players from other clubs followed their example.

Almost 20,000 young men from Edinburgh had joined the forces by the end of 1914, according to Sir James Leishman, who also spoke at Sir George McCrae's meeting. Thanks to the Portobello Annual Club, we have a pretty accurate estimate that the number of persons from the town who had joined the forces by the end of 1914 was

almost 800. In addition to organising the fundraising concert on 23 December, the Annual Club set itself the task of compiling a Portobello Roll of Honour, a list of the names of all those serving together with the names of their units. Information was sought from families and friends, local churches, societies and organisations and an appeal for help was printed in the local paper. The list was printed as a booklet for sale, with the proceeds going to swell the welfare fund, and was printed in full in the *Portobello Advertiser*. The club president said,

> It was the duty of communities to remember those who had left their homes to fight for their country … The Club had also by its work in compiling the Roll of Honour placed Portobello in a very proud position by making known to the public the large number from the locality serving their country, a number that far exceeded the most optimistic estimate.

A copy of the Roll of Honour was sent to the about 800 persons whose names were on the list. Just over 100 of those were serving at the front, at home wounded or prisoners of war, and they received in addition a knitted woollen balaclava helmet, a pair of mittens and a cake of shortbread. The club also reported that £5 was shared among the 'dependants of the five men killed at the Front'. Some of the recipients sent letters of thanks to the Annual Club and these were shared with the general public via the *Portobello Reporter*.

LETTERS FROM PORTOBELLONIANS AT THE FRONT

Nurse Margaret McKinnon Suding, No. 141 Stationary Hospital, Rouen: 'I received the copy of the Portobello Roll of Honour sent by your Club today. Please accept my best thanks for it and the good wishes it contained.'

Nurse C. B. Robb, General Hospital, Boulogne: 'Those who are privileged to be at the front are very grateful to the homeland for the many kindnesses.'

Drummer Fred Simpson, 2nd Gordon Highlanders: 'It gives me great pleasure to acknowledge receipt of the parcel containing 1 pair mitts, 1 Balaclava cap, and cake of shortbread. I received it three nights ago when my Company came out of the trenches, and Mrs Baillie's shortbread (I take it to be Mrs Baillie's) proved very enjoyable. The mitts and cap are just the thing for the trenches in this sort of weather. When I have them on I will always be thinking of Portobello. I never thought until I saw the Roll of Honour that there were so many servicemen in Porto. I will close now, thanking the Portobello Annual Club for its kindness.'

Corporal Jack Aynley, Base Details, 1st E York Regiment, 6th Infantry Base Depot, Havre: 'Just a line to thank you for the New Year's gift from the Porto folk. I only received it yesterday. It was all right, and you can guess how the shortbread went down. There were about ten of us had a share in it, but it was good. Of course, we always, as we say "muck in" when we get parcels, so that if one gets a parcel one day and another the next, we often have a decent pipe of 'bacca or a tasty piece of cake, and we get on all right. We are having rotten weather – it rains every day.'

Private W Cassidy, Royal Inniskilling Fusiliers: 'Just a note to let you know that I received the parcel. It was very kind of you to send it out to me, and some of the lads and I enjoyed the cake very much. I was also glad to get the mitts and helmet as it is very cold and freezing at present, and it was wicked in the trenches … I am sure that all at home are proud to see such a Roll of Honour from so small a town as Portobello. I have been in France since 26th August, and we have had some rough times of it. I had my baptism of fire when I was only six days in France. I got my rifle smashed by shrapnel and my water bottle carried away when crossing a plain. One day in a wood I got a bullet clean through my cap, smashing the wire off it, but God was good, and I got over it all right. On the 20th or 21st October we had an attack in which we came off best. Some of us could not get up to the firing line, and we took cover in an old farmhouse. We had not been five or ten minutes in it when a shell found us out, and the house was knocked to matchwood. Two of the lads were killed and one wounded out of the eleven of us. I thought it was all up with me that day, but no, God was good to me, and has carried me through it so far. I think if I am spared in health and strength I will spend St Patrick's Day in Portobello along with the rest of the boys of good old Pipe Street.' [Private Cassidy died on 29 May 1916 and is buried in Philosophe British Cemetery, Mazingarbe, Pas de Calais, France.]

Corporal W. Bold, 2nd Scots Guards: 'I can hardly express my gratitude to the members of the Annual Club for the present I received on the 3rd. It does a lad good to know that people in his native place are doing their utmost for their comfort whilst out here. I got a big surprise to see so many names in the Roll of Honour, and I think Portobello has done exceedingly well in responding to the country's call. I must close now as I have heaps of work to do to see that my section gets dry clothes.'

Brothers William and David Robertson, 1st Cameron Highlanders, wounded at the Battle of the Aisne: 'We send this note to let you know that we received your nice present and send our best wishes to the Annual Club for their kindness.'

Private T. Creamer, 2nd Seaforth Highlanders: 'Just a few lines hoping this finds you in the best of health as it leaves me at present. I received your parcel all right, and was so thankful for it. We are having very bad weather just now, but we have to put up with it. Just now the regiment is out of the trenches having a bit of a rest. We had a very enjoyable Christmas, but the New Year was a bit quiet. On Christmas one would have thought that peace had been declared, as the Germans turned very friendly. It started with wishing each other a merry Christmas, then there was singing all along the line. The Germans have their bands with them, and so they gave us some nice selections, which were a treat to listen to. Now things are the same as before.' [Private Creamer, of 8 King's Road, died on 25 April, 1915, aged twenty. He is buried in the Seaforth Cemetery, Cheddar Villa in Belgium.]

This is a representative selection from the letters that the paper printed. They differ in style and tone, but all agree on how uplifting it was for their writers to know that they were remembered and how grateful they are to the Annual Club and all concerned. For some, receiving the Roll of Honour was appreciated almost as much as the mitts, balaclava and Mrs Baillie's shortbread. Seeing their name among so many others made

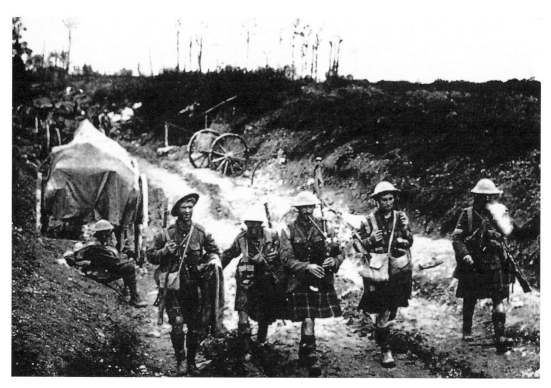

Scottish troops marching out of the front line.

them feel that they were part of a special group and proud to be from a small town that was sending out more men than might be expected for its size. The letters are also a reminder to those at home of the conditions and dangers being endured day in day out by the troops, and, surely, no one could fail to be moved by Private Creamer's poignant sentence ending his account of the Christmas truce.

As the war moved into 1915, although the real horrors were still to come, casualty lists were becoming longer and some deaths were being reported in detail. This is from the *Edinburgh Citizen & Portobello Advertiser* of 15 January:

PORTOBELLO SOLDIER'S HEROIC DEATH

Private J. B. Waddell, 6th Royal Scots, whose death is announced, was one of Portobello's heroes, his fatal wound being received in an attempt to rescue a wounded comrade. He was 20 years of age, and was a member of the 6th Royal Scots to the Service Battalion of the 8th. A chum of his was wounded in the legs and was unable to regain the shelter of the British trenches, and, hearing his cries for assistance, Waddell left his position of comparative safety to bring his comrade out of danger. There was a hail of lead sweeping across the ground from the German trenches 200 yards away; his bravery was not proof against danger, and he fell with bullets through his head and heart. Mr J. B. Waddell, 25 High Street, Portobello, the grandfather of the dead soldier, has a melancholy memento

of Private Waddell's last hours. This is a postcard which runs – 'Dear Grandparents, –We are having very hard weather here. I am about fed up with it–' here the writing ceases, Waddell's task having apparently been interrupted. He had placed the card in his pocket hoping to finish the note at some other time, and the bullet which found his heart tore its way through the card. It, along with other belongings, was sent home to Scotland. After church service on Inchkeith, Captain Milligan, the Commanding Officer of Waddell's old company, read the portion of the letter from the front telling of the death. As a mark of respect to their comrade, who so nobly sacrificed his life, the audience stood to attention. The writer of the letter, Lieutenant Turner; who, since Captain Todd was wounded, has been in charge of the Service Company, speaks of Waddell as 'a good soldier and a real nice chap'. In one of his letters Captain Todd said that the only complaint he had to make against his men was that they were 'too rash and daring.'

In the last week of January it was reported that Able Seaman James S. Gow RNVR had been drowned when HMS *Viknor* sank off the north coast of Ireland with the loss of all on board. Before the war, he was an apprentice fitter in a Leith shipyard and had been a Corporal in the 3rd East Edinburgh (Portobello) Troop, Boy Scouts attached to St James' church. Gow was already a member of the RNVR so was immediately mobilised. The sudden influx of its reservists posed a huge problem for the Navy, all its warships were fully manned so thousands of men had nothing to do. Winston Churchill, First Lord of the Admiralty, ordered that they were to be used immediately to create a new formation to bolster the hard-pressed British land forces in Europe. This was the Royal Naval Division, made up of two brigades, each of four battalions. James Gow was transferred to the Anson Battalion in the 2nd Brigade and the two Brigades moved to Dunkirk to aid the defence of Antwerp on 5 October 1914, but the British forces arrived too late to affect the outcome. The siege of Antwerp lasted for eleven days, but after heavy fighting the city was taken by the German Army. Gow was reported in *The Scotsman* to have distinguished himself during the fighting:

> When volunteers were called for to make up a gun's crew in a redoubt in the Antwerp defences, Gow, who was in his nineteenth year, stepped forward, and for four hours did good work till the order came for retirement.

Belgian and British troops retreated westwards and James Gow and the Anson Battalion managed to return to England on 11 October 1914. He was transferred out of the Anson Battalion at the end of October to return to sea duties. After a spell of leave at home with his parents in Bath Street, James had left on 30 December to report to HMS *Viknor* as a member of a gun crew. *Viknor* had been a passenger liner of some 5,300 tons, originally named the *Atrato*, owned by the Royal Mail Steam Packet Company. She had operated between Britain and the West Indies from 1889 until 1912 when she was sold to the Viking Cruising Company and renamed *The Viking*. She was requisitioned by the Admiralty for war service in 1914, converted into an armed merchant cruiser with a new name, HMS *Viknor*, and assigned to the 10th Cruiser Squadron patrolling the waters between Scotland and Iceland.

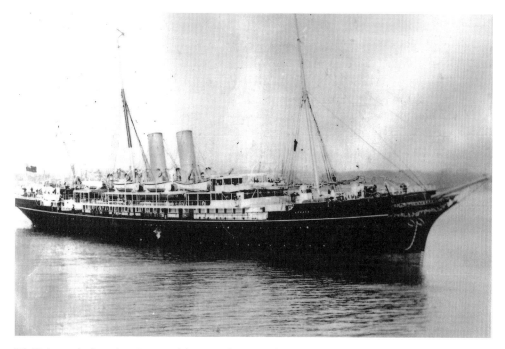

RMS *Atrato* before the First World War. (*Photograph courtesy of Keith Ahmed*)

On 13 January 1915, the *Viknor* disappeared near Tory Island off the north coast of Ireland and James Gow and all others on board were drowned. There were 291 naval personnel, which included twenty-five Royal Naval Reservists from Newfoundland and a significant number of hired Merchant Seamen, a large proportion of whom originated from Tyneside. Also on board were a German intelligence agent, Baron Hans Adam von Wedell, and six German military reservists. They had been found with false passports on a Norwegian passenger ship stopped and boarded while on its way to Europe and were being taken to Liverpool. Some bodies were washed up on the Irish and Scottish coasts over the following days, but Gow's body was never found. His name is on the panel of the Portsmouth Naval Memorial that is dedicated to those sailors who in World War One, 'laid down their lives in the defence of the Empire and have no other grave than the sea'. James Gow's 1914 Star was issued to his father in July 1919.

Why the ship sank has never been fully explained; no distress signal was sent, although she was in wireless contact with the shore. There was a violent storm that night and *Viknor* was close to a German minefield, but whether it was one or the other or a combination of both has still to be proved. In 2006, the wreck was located by the Irish survey vessel, *Celtic Explorer*, at the edge of the German minefield, perhaps giving some credibility to the speculation that she had struck a mine. In 2011, a group of Irish divers went out on the diving vessel *Rosguill* to the *Viknor*, lying 85 metres down on the sea bed, and laid a White Ensign on her in memory of all those who died. This had been requested by the great-nephew of Vernon Lickfold Matthews, the ship's surgeon.

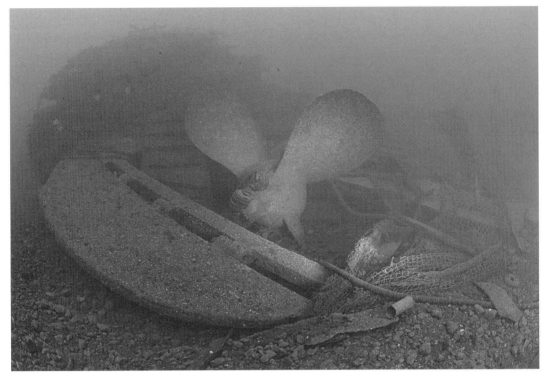

The rudder, propeller and stern of HMS *Viknor*. (*Photograph courtesy Barry McGill & www.rossguill.com*)

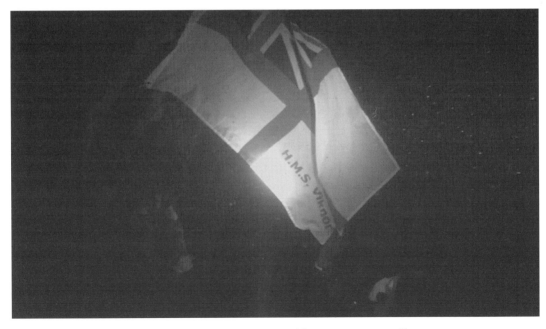

Laying the White Ensign. (*Photograph courtesy Pat Coughlan & www.rossguill.com*)

There was understandable concern felt by many in Portobello about the possible consequences of having so many troops billeted either in or near the town. It was not that they were unused to seeing soldiers on their streets; cavalrymen and their horses, from nearby Piershill Barracks, had been regular visitors since the nineteenth century. Now, however, the numbers were much greater; in addition to Piershill, there would be soldiers stationed at the Marine Gardens, the former Chocolate Factory and a camp at Duddingston, and what was there to occupy their off-duty time? The fear, and it was not unspoken, was that a large majority would gravitate to the public houses and other licensed premises which Portobello, as a holiday resort, had in plenty. What was required was somewhere that, for those that wanted, could provide refreshments that were non-alcoholic, quiet space for reading and writing letters home, and perhaps space for entertainment. Thanks to the enterprise of Portobello Temperance Council and the generosity of St Philip's United Free Church of Scotland, suitable premises were found. The Deacons' Court of the church granted the use of its Pipe Street Mission Hall free of charge to the Temperance Council to be run for the benefit of soldiers in their off- duty time. The Temperance Council, aided by volunteers from local churches, lost no time in getting the premises ready for use on the evening of 13 November:

> From the cold interior of a Boys' Brigade Drill Hall, to the cheerier atmosphere of a recreation room, or home-club, was the change of scene wrought by the deft hands of many Portobello ladies, to whom the work proved congenial.
>
> All being in readiness for Friday night of last week, an opening social and concert was announced for the large hall, and invitations of welcome sent out to the likely quarters.

With the hall ready and the catering organised, W. M. Ramsay, JP, President of the Temperance Council, his volunteer helpers and the platform party could only wait to see whether or not their efforts would be met with success. As the report describes, initial gloom was replaced by relief:

> What the feelings of those were … as the hour approached may be imagined, with not a single guest present, and time more than up. Then came the uplifting report from an excited messenger, 'There's yin comin'. This one proved, however, to be the forerunner of many others, and when the platform party entered they found the front forms occupied by two score khakied Terries, exercising their lung power vociferously in a tuneful rendering of, 'It's a long long way to Tipperary'.

When the singing had stopped, and after a short blessing, tea and cakes were handed round the company. During this, some took themselves off to inspect what was on offer in the lower hall. Here they found tables laden with books, magazines and newspapers, others with parlour card games, chess, draughts and dominoes, and three bagatelle boards. An area was set aside to provide somewhere where a letter or card home could be written in comparative privacy, and to cap it all there was a piano in the corner. Then it was upstairs to rejoin the others and catch Mr Ramsay's opening

address, which was punctuated throughout by loud and prolonged cheering. At the end, 'the exuberance of the men broke forth, and after again indulging in their war song they calmed down for those who were to follow.' Unfortunately, peace did not reign throughout the concert and it had to be stopped part way through to allow 'an invasion of belated territorials' to come in and take their seats. More tea and cakes were served before the programme continued to its end when the performers received prolonged and well-deserved applause.

For the time remaining, those who wanted were able to go downstairs and browse among the tables and even sample the goods. The piano was quickly spotted and a short impromptu concert got underway before the guests had to leave. What was described in the local press report as 'an interesting first chapter in a promising story' was over. There would have been sighs of relief but Mr Ramsay and the others had good cause to congratulate themselves. The Territorials may have been overenthusiastic and more than a trifle loud during the concert, but they had also been shown what was available to entertain themselves in surroundings that reminded them of home, and liked what they saw. So the evening had been a success and the Pipe Street Institute became more of a bestseller than a promising story, as shown by this brief newspaper notice two years later:

PIPE STREET HALL
'SOLDIERS' HOME'

The work in this hall is as popular as ever. The soldiers simply crowd in and make the place their 'home from home.'

Exactly what the originators had hoped would happen.

A short while later, on 23 December, a second institute was opened in the Marine Gardens. This was a new wooden building measuring 38 feet by 75 feet, capable of accommodating 600 men, which had been provided by the Church of Scotland Young Men's Guild. It offered the same facilities as the one in Pipe Street but on a larger scale and, like its predecessor, was a success from the outset, as can be seen from the *Edinburgh Citizen & Portobello Advertiser* of 15 January 1915:

This institute, since its opening three weeks ago, has amply justified the wisdom of its promoters. The building is being used by the men in a way that indicates a felt want has been well met. The facilities for writing and reading seem to be a boon and a blessing. Over 5,000 letters and postcards have been posted in the Cinema House letter box, and night after night the reading room tables are surrounded, magazines, papers etc., being much in request ... A cup of tea, coffee etc., served by willing workers from the Portobello Temperance Council, church workers, Guildsmen etc., are provided at certain periods of the afternoon and evening, and the refreshment counter presents a busy scene ... a series of concerts are arranged and are being given. On Tuesday evening Mr Fred Borthwick and friends provided the concert. Mr W. M. Ramsay, who presided, in his opening remarks, referred to the generous

kindness of professional and other musical friends in so willingly giving their services [and] in referring to the success of the institute he remarked that whether they called it a house, a hut, or a bungalow, it was too small. 'It is a palace,' shouted a soldier, and all around the cry, 'It's a palace to us,' was raised, and this speaks volumes as to the feeling of the men in regard to the institute.

From now on, the Institute was locally known and referred to as 'Tommy's Palace'. When another military institute was erected by the Young Men's Guild, this time at the Chocolate Factory, in June 1915 it became 'Tommy's Palace 2'. At first, this was a marquee that could seat 500 men but this was replaced by a large wooden hut in November. W. M. Ramsay became honorary superintendent of this institute as well as the one at the Marine Gardens.

William McCulloch Ramsay, the driving force behind the founding and organisation of the military institutes, was born in Fife in 1854, but when he was very young was sent to live with an aunt in Portobello. By his own admission, he was 'without much schooling' and, after serving an apprenticeship at Buchan's Pottery, had a variety of jobs including on the railways, and also opened a fruit and vegetable shop on the High Street. He eventually found a post that satisfied his concern for the education and wellbeing of young people, and his temperance ideals. This was as an agent with

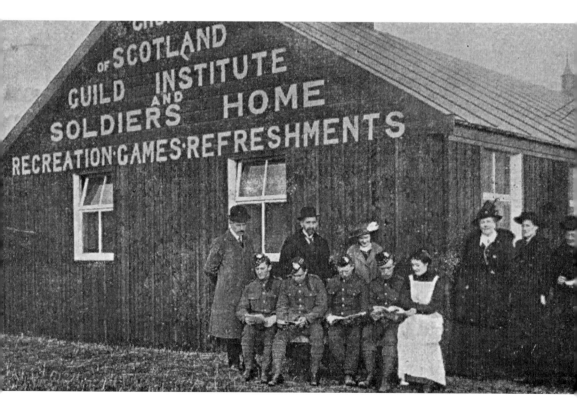

the Hope Trust, which had been founded by John Hope, an Edinburgh lawyer and philanthropist, in 1847 as the British League of Juvenile Abstainers. It was aimed at working-class children and members took a pledge, usually at the ages of six or seven, of total abstinence from alcohol, tobacco and opium, and promised to study the Bible. The trust's literature and activities, as well as graphically detailing the 'evils of drink', also strenuously promoted Protestantism. As an agent, Ramsay travelled round 'spreading the word' by addressing meetings of adults as well as children. In Portobello, he founded a youth organisation called the Ramsay Bible Guild. Although its core purpose was to foster discussion of the Bible, the guild was concerned with the whole person and had sections for debating, football, swimming, cycling and social activities. He served on the Edinburgh School Board from 1909 and became Convener of the Continuation Classes Committee of the Education Authority.

The local organisers found that some of the most enjoyable concerts were those where the entertainment, either whole or in part, was provided by the soldiers themselves. Many of the volunteers had been professional, or semi-professional, musicians, singers and entertainers of various sorts, and some battalions formed concert parties that performed for local groups and charities. This advice was passed on to householders offering hospitality to soldiers:

> Mrs Grieve of Coillesdene, who has ample scope in this direction by reason of her very commodious premises, has given several of her rooms for the entertaining of the youths from the Chocolate Factory. Here the lads are on occasion allowed to smoke, read, write and play various games, while refreshments are served up before their departure for the barracks. The Territorials, Mrs Grieve observes, do not altogether appreciate a musical evening, when a programme is arranged and artistes engaged. They enjoy much better a free-and-easy evening, where they are allowed to smoke and carry out their own arrangements. Many of them, she says, exhibit very good musical talent and it does not take much of an effort to fill in an evening in this direction. We commend this example to the notice of other ladies who have the opportunities perhaps and the wish to do their little part at a time like this when the streets are not the most enjoyable of places to be on a cold rainy night.

Mrs Marion Grieve, mentioned earlier in this chapter, was a very wealthy lady who had been an active member and generous supporter of many charities and good causes in Portobello over the years. She was also an energetic campaigner for women's rights and a militant suffragette, who in December 1911 was one of the Edinburgh contingent who took part in the mass demonstration at the House of Commons, during which two of its six members were arrested. Local tradition has it that before setting out on a demonstration she collected suitable stones from Joppa Beach to put in her bag. Like other members of the movement, she gave up campaigning and militant activity on the outbreak of war and put all her energy into local fundraising for the welfare of those affected by the war. In this, she was one of the many in Portobello who, by spring 1915, were doing their bit on the home front and continued to do so until the war ended.

CHAPTER 2

THE HOME FRONT

The First World War was the first fought by Britain that directly impacted on the daily lives of the civilian population away from the battlefield. There were difficulties caused by disruptions in the supply and production of foodstuffs and loss of labour to the armed forces. How these were handled in Portobello is dealt with in later chapters; here we examine the war's impact on Portobello as a holiday resort and in its less well known role as a commuter town.

There were other resorts in Scotland that had fine sandy beaches and good sea bathing, but Portobello in the years prior to the outbreak of war had two unique assets when it came to attracting visitors: its promenade pier and the Edinburgh Marine Gardens and Zoological Park. No other seaside resort in Scotland had similar attractions and, although built almost forty years apart, both owed their existence to the vision of individuals anxious that Portobello should remain the pre-eminent holiday destination in Scotland. However, both became casualties of the war.

Portobello's popularity and prosperity as a resort was at a high going into the third quarter of the nineteenth century, but some prominent figures in the town feared that it could lose business if it continued to rely solely on the quality of its beach and sea bathing. The railways that carried the trippers to Portobello could just as easily carry them to the seaside towns in England, where promenade piers were being built in large numbers and drawing in the visitors. Perhaps it was time for Portobello to have one. Negotiations between the council and the railway engineer Thomas Bouch resulted in the formation of the Portobello Pier Company, and construction began after approval by Parliament in July 1869.

An enthusiastic crowd gathered on 23 May 1871 for the opening of the new attraction, a promenade pier stretching 1,250 feet out into the Firth of Forth with a restaurant, bar and concert pavilion at its end. At 1*d* for admittance, the pier proved a very popular attraction with trippers, and locals could buy annual or monthly season tickets. Portobello was now also connected to towns such as North Berwick in East Lothian, Aberdour, Elie and others in Fife by sea, as the new pier meant that excursion steamers could visit Portobello regularly. A trip out into open water on a paddle steamer was a must for many holidaymakers.

Despite its popularity, the pier was never a paying proposition. Shareholders received dividends for some years, but the increasing cost of repairing damage caused by the winter weather of the Firth of Forth forced the winding up of the company. The pier was bought by the Galloway Saloon Steam Packet Company, who operated the excursion steamers, for £1,500 in 1891, but the new owners were no more successful than the old. The pier was forced to close for repairs on numerous occasions, but struggled on until 1917, when storm damage was so severe that it was declared unsafe. The owners were refused a permit to buy wood and other materials to carry out the necessary repairs by the Ministry of Munitions, and in December 1917 advertised for tenders to demolish and remove the structure from the beach. This provoked an outraged response from a reader who expressed the feelings of many:

> Surely the city authorities will not allow the pier to be removed without first considering the desirability or expediency of acquiring it for the benefit of the citizens, as well as looking into the right of the Galloway Saloon Steam Packet Company to dispose of the structure in such an arrogant and high-handed manner. Considering that the pier was constructed by the authority of Parliament, can it be removed, demolished, or otherwise ended without permission of the same authority, duly obtained?

The city authorities declined either to take over the pier or intervene by approaching Parliament to test the legality of the sale as shown by the following, which appeared in Portobello's local paper on 1 February 1918:

Seaside Jottings

Portobello Pier is after all to be demolished.

*

Estimates for the work have been accepted.

*

Portobello people are in two minds regarding its disappearance.

*

One section of the public would fain retain it as a picturesque feature of the beach.

*

Others are inclined to think that its remaining prevents the Corporation at a future period going in for a really substantial structure.

*

Meanwhile it is not quite safe for public traffic, and there is no possibility of getting a permit to repair it.

*

And we do not wonder that the charges for rates and taxes on a non-paying structure have been found somewhat burdensome.

*

Originally the pier cost somewhere about £10,000 or £11,000.

*

Galloway Steam Packet Company became owners some years ago, the price paid the Pier Company being £2,000.

It is at least open to question whether Galloway really wanted to repair the pier and make it serviceable again. They must have known that it would continue to be a loss-making enterprise, and one suspects that they only went through the motions of applying for a permit to buy materials secure in the knowledge that there was very little chance that it would be granted. It was the end of an era, but there were those who dared to hope that one day something similar, but grander, would take its place.

The 1914 *Guide to Portobello and District* described the Marine Gardens as 'inseparably associated with Portobello ... the first large amusement park put up permanently by Scottish enterprise'. The idea of such a park was conceived by a group of businessmen anxious that the buildings put up in Saughton Park in Edinburgh for the 1908 Scottish National Exhibition should not be demolished when it ended. They bought the buildings and transported them to 30 acres of seafront land they had leased at Seafield, west of King's Road, and opened to the public on 31 May 1909.

The park was an immediate success, drawing 750,000 visitors in its first year. Its attractions were many and varied, and the *6d* entrance ticket brought with it free dancing in the ballroom and a free seat in the Al Fresco Theatre and the cinema. It cost

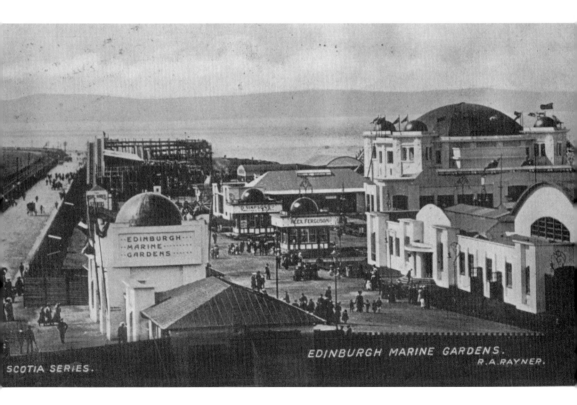

SCOTIA SERIES.

EDINBURGH MARINE GARDENS.
R.A.RAYNER.

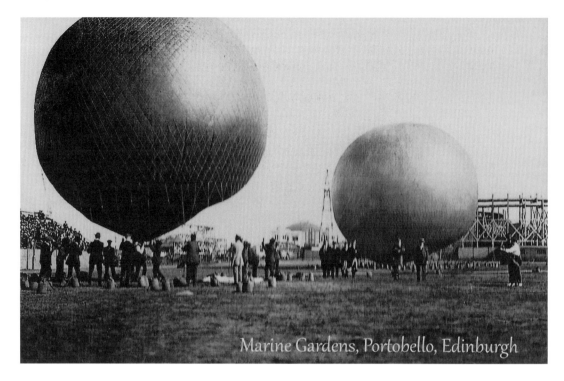

Marine Gardens, Portobello, Edinburgh

another penny to go into the fairground. For those travelling by rail from Edinburgh, there was a special combined travel and admission ticket costing 7*d*. The designers of the Marine Gardens were well ahead of their time in their conception of what should be provided for holidaymakers in the mass – there was something for all tastes. The striking, domed Concert Hall, which could house an audience of 3,000 people, hosted opera, musical comedy, top class variety and films. The open-air theatre catered for those who preferred concert parties, Pierrots and the jokes of popular Edinburgh comedian Henry Farrow, and in the Band Court one could listen to selections played by military bands and famous brass bands from England and Europe. On fine days, it was pleasant just to stroll along the wide pathways round the large areas of grass and flower beds. The Empress Ballroom and Roller Skating Rink attracted thousands of customers in their own right.

A number of spectacular attractions were staged to bring in customers. One favourite was Daredevil Cormack, who dived from a 70-foot tower into a small tank of water, and another was Captain Spence, who made daily ascents in a hot-air balloon then thrilled the crowd by making a parachute jump into the sea to be rescued by a waiting boatman. Interest in aviation was increasing all over Britain at this time, and flying displays had become popular attractions. In August 1911, W. H. Ewen came to the gardens to give exhibition flights and perhaps attempt a flight across the Firth of Forth. Throughout the month, if you were not watching the amateur gymnastics and wrestling in the sports park, you could view his monoplane for 3*d*. A little before darkness set in on the evening of 30 August, Ewen, who was associated with the flying school at

Lanark and was the only Scotsman to hold a pilot's licence, took off for Burntisland. The weather that week had not been encouraging owing to strong and uncertain winds but, on the 30th, the wind apparently died down to some extent and he announced that he was to attempt to fly over the Forth. After he had taken off from the sports ground and was over the Forth, he found the winds were still tricky and made steering difficult. However, he reached Kinghorn, turned and headed back towards Leith. Around the middle of the Firth, he left the calm belt and hit variable and dangerous winds that caused the plane to rock and dip. He afterwards stated that on this part of the return journey he had a bad five minutes. Ewen wanted to land in front of the spectators on the sports field close to where he had taken off, but was forced to pull out of his descent when a gust of wind caused his plane to heel over. To avoid any damage being caused to the machine, he took it over the heads of the spectators and, after a short flight past the grounds, landed safely in a level field to the west. The news of the flight attracted large crowds to the Marine Gardens in the evening and Ewen had an enthusiastic reception when he got back. The crowd demanded a speech, and Mr Ewen said a few words of thanks for his reception and expressed satisfaction that a Scotsman had been able to do something in the way of mechanical flight. The following year, again in August/ September, flights and demonstrations by the French flyers Caudron and Marty were similarly beset and disrupted by strong and contrary winds. Safe landings were loudly cheered, but after one particularly hair-raising demonstration Marty declared he had just had the narrowest escape he had ever experienced.

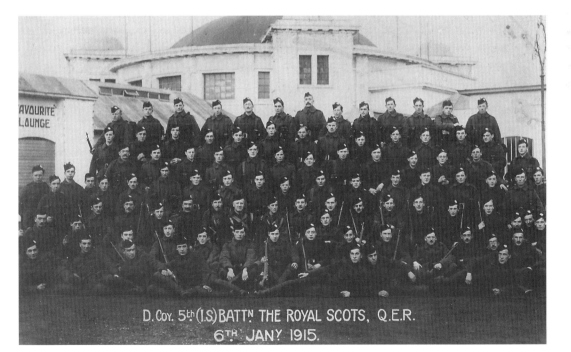

D. Coy. 5th (I.S) BATTⁿ THE ROYAL SCOTS, Q.E.R. 6ᵀᴴ JANY 1915.

The writer of the 1914 *Guide* justifiably considered the 'Marines' to be the jewel in Portobello's crown, but did not realise that he was, in fact, writing their obituary. The last official event at the Marine Gardens in 1914 was the Edinburgh Aero Club's model aeroplane exhibition on 9 August. True to form, strong winds and bad weather spoiled the demonstration flights. Several of the models, which were driven by twisted rubber bands, were carried out to sea and lost in the Firth of Forth. However, before the competitions were abandoned, spectators were treated to some interesting flights by the tiny monoplanes and biplanes. After the exhibition closed, the Marine Gardens were requisitioned by the War Office as barracks for the Territorial Army and the first to move in were local Territorial battalions of the Royal Scots. In his monumental *Edinburgh Theatres, Cinemas and Circuses, 1820–1963* George Baird described his arrival and departure from the Marine Gardens:

> In 1914 the Marine Gardens became a glorified 'Lodging House'; I was one of those to make use of its facilities. My first visit to the Marine Gardens was in the autumn of 1914 and it came about thus:
>
> I joined the 5th Royal Scots, Territorials, on 24th March 1910; my regimental number was 1079. I could not have wished for a better company of comrades. Captain McLagen was the Officer Commanding 'A' Company, with Lieuts. Turnbull and 'Bertie' Maule, both killed at the Dardanelles. Lieut Maule, son of Sir Robert Maule, draper etc., West End of Princes Street was killed a few yards from me.
>
> The battalion mustered in the Moray Maltings, off London Road, in August 1914; from there we went to Redford Barracks; then to Craiglockhart School; and finally to the Marine Gardens, the Ballroom, which at the moment of writing I see from my living-room window [Wakefield Avenue] on 24th August 1963. A number of other places in the Gardens were used as sleeping quarters by 'other ranks.'
>
> The battalion marched out of the Marine Gardens on the evening of Tuesday March 10th 1915, at 9 p.m. The Band of the 9th Royal Scots played us to Portobello Station. I was fortunate to see my mother in the crowds lining the pavements. The next time I saw her was in 17th General Hospital, Birmingham University, in July 1915.
>
> The troop train left Portobello at 10.35 p.m. for an unknown destination. Rumour had it here, there and elsewhere. In any case, the 5th Royal Scots, the only Territorial Battalion in the 29th Division, 88th Brigade, landed on the Dardanelles on Sunday morning, 25th April 1915. I left the Dardanelles on 6th May 1915, after having been wounded twice.

Members of George Baird's battalion returned to the Marine Gardens on 20 December 1915. They were the guests of honour at a celebration of the anniversary of the opening of the Church of Scotland Guild Military Institute, 'Tommy's Palace'. The celebration took the form of a reunion tea and concert for the soldiers who had been the first to enjoy its benefits, but those present were just a remnant of the battalion that had marched out on 10 March. Captain McLagan DSO, who was cheered for several minutes, thanked Mr W. M. Ramsay and the organisers for the opportunity to come back to their old quarters on the anniversary of the opening of the place, which had

The message on the reverse says, 'This is the room in which I sleep. I have put a cross over where I sleep.'

given them more happiness and comfort than Mr Ramsay or his friends could ever believe. He acknowledged that there was a feeling of sadness being here, but said that their job was to get fit and go back to the trenches as soon as possible.

The 31st (Reserve) Battalion Royal Fusiliers, formed in Essex in September 1915, was just one of many units stationed at the Marine Gardens, but being a training battalion it was there for a lengthy spell and formed close links with the community. Although it was absorbed into the newly created Training Reserve on 1 September 1916 as the 107th Training Battalion, it remained in Portobello, whose residents stubbornly continued to refer to it as the 'Fusiliers'. Its band played to large audiences every Sunday afternoon during the summer at the Bandstand on the Promenade as well as giving concerts at the Town Hall for charitable causes and supporting other events. From its ranks it could produce top-class artistes such as Sergeant H. Child, a well-known baritone from London's Queen's Hall, and Lance-Corporal Edward Victor, a skilled conjuror who had performed with Maskelyne and David Devant. On 31 August 1917, a special farewell concert in the Town Hall, attended by the Lord Provost, was afforded the battalion when it left the Marine Gardens to return south. Colonel Lord Crofton, commanding the battalion, said they had received nothing but kindness in Portobello. He could not express the indebtedness of the battalion to the helpers in the Guild Hut and, in the name of the officers and men, he presented a piece of plate to Portobello.

The Royal Air Force, formed in April 1918 by amalgamating the Royal Flying Corps and Royal Naval Air Service, came to the Marine Gardens late in the same year when

Stores Distributing Park, Royal Air Force, Portobello, November 1918.

the Army had no need of it as a barracks. With the RAF came members of the Women's Royal Air Force, which had also been formed the previous April, and together they made up the establishment of No. 9 Stores Distributing Park, Royal Air Force. By the end of the year, 9,000 women had been recruited to work as clerks, fitters, drivers, cooks and storekeepers, but the WRAF was disbanded after the war.

The occupation of the Marine Gardens by the military was sudden and complete. At a stroke, the Edinburgh Marine Gardens Company lost the use of all the land and the buildings that it had erected on it. The funfair was not allowed to operate and all those running sideshows, cafés, stalls or any kind of concession had to close them down. The consequent loss of income caused difficulties for all concerned. In June 1916, Edinburgh Parish Council, the body that collected Edinburgh's rates, reported that those in respect of the Marine Gardens were two years in arrears. In answer to a question it was said

to be 'owing to the place being in the possession of the military'. On 14 December, the company that owned it advertised that the Figure Eight Railway was for sale with all its equipment. By the end of January 1917, it had gone into liquidation.

The Marine Gardens Company contended, with some justification, that the terms of the government contract for the military occupation of the property were extremely unfair. It also contested the government's belief, when it took over, that the amusements could not be operated because of wartime lighting regulations by pointing out that most business was done between May and September when lighting was not a concern. Between rent and taxes, the company had an annual liability of over £1,000 and the government paid it £400, having taken over buildings worth £50,000. The dispute dragged on through the courts until, in May 1918, the two parties agreed an out of court financial settlement that was very favourable to the Marine Gardens Company, and in addition the Court of Session ruled that it was also entitled to expenses. However, the gardens remained closed to any non-military use.

The closure was good news for William Codona, the owner of Fun City, further east on the promenade, the only other fairground in Portobello. Neither the war nor lighting regulations stopped it operating and business was brisk, especially when the weather was fine, and this was the case for Portobello's holiday trade generally. Accounts suggest that early in the war there were fewer day trippers, but that the number of visitors coming for an extended stay held up well. The longer the war lasted, the more pre-war patterns were re-established. In particular, the annual July influx of Glaswegians during their Fair holiday week was maintained. Despite the war, many Glasgow trippers travelled through to Portobello for the Glasgow Fair holiday in 1915, and particularly on the first Saturday night, Portobello was unusually busy. Special trains were run and most had their full number of carriages. In showery weather, the number of people waiting at the tram terminus at Waterloo Place was so great that police had to be in attendance to keep order. The situation was not helped as the whole cable tram network in Portobello ground to a halt when one of the cables snapped. It took six and a half hours before the section was again opened for traffic.

After three years of war, the number of Glasgow visitors reached a record level in 1917. During the week, trains brought day trippers to Waverley and Princes Street stations and the trams carried 22,000 passengers from Edinburgh to Portobello. Many of those who came at the beginning of the week with the intention of renting an apartment, but had not made a booking, found there was nothing to be had. Ransom prices were offered for rooms and in small houses – rooms were fetching as much as £2 10s for the week. This left some of the visitors stranded and many were forced to leave to find lodgings in Edinburgh or further afield. Others spent the night in the open; some of these walked about, but the police reported that about 400 people had slept on the beach.

The demand for bottled beer was enormous and stocks in several places were practically cleared out at the beginning of the week. In an article on the scenes in Portobello, *The Scotsman* reported on the food and drink situation:

> The shopkeepers are handling an abnormal trade, and yesterday in some cases new consignments of beer were cleared out in the selling period. Whisky is also in demand.

These are available, but sugar is proving a great difficulty. Many of the visitors have brought sugar and other provisions with them, but some are now using condensed milk to make up for the lack of sugar, the supply of which – and it was only the brown variety that was on sale – gave out in some shops on Saturday forenoon. Otherwise there is no scarcity, and the holiday-makers are not stinting themselves. They pay for the best butter, the best eggs, and the best of everything.

The holiday influx was described in military terms. It was an 'invasion' and the visitors 'have taken over a considerable portion of the [Portobello] front. They have more or less made it their own.' The shore and the Promenade were crowded and there was scarcely room to move on the beach around the pier. 'It was a typical Glasgow holiday scene,' continued the reporter.

The younger element in the throng – and there was a noticeably numerous proportion of young men – were enjoying themselves somewhat strenuously … These youths, for the most part, were in parties of half a dozen or so, and they made things lively. With the well-known penchant of the Glasgow tripper for carrying his own music with him, several of these coteries had the inevitable melodeon. The showground was largely patronised, and the proprietor had no need for balancing the loss on the swings with the return on the roundabouts. Both, as well as all the other fun of the fair, were flourishing exceedingly. There did not appear to be anything for sale that lacked purchasers … They were enjoying themselves with their native abandon … Men, women, and children were wading with the enthusiasm that is familiar on Clydeside. They undertook it as a rite. It was altogether a happy, joyous multitude, and the greatest of their blessings was the warm sunshine, of which they had plenty.

Although reading the account might lead one to think that residents of Portobello would have been wise to avoid the promenade during the fair, and also raise eyebrows at so much extravagance, the article is not disapproving of the scenes of exuberance and high spirits. If it is judgemental, then it is on the side of the Glaswegians:

Glasgow has looked forward to this respite as it seldom did before. The city's war workers have been hard and constantly engaged in providing the essentials for the great conflict, and now that they have been able to lay down tools for a few days, they are out to make the best of their time. From shipyard, munition work, and engineering shop they face the enjoyments of the week with a bulkier pocket than probably ever before. In their own words they are 'flush' and are out to have a good time. Money has evidently been no obstacle. Increased railway fares, enhanced terms for rooms, and dearer food have made no difference. Glasgow and 'the wife and weans' have gone to the coast willy-nilly.

Portobello was similarly crowded with Glasgow Fair holidaymakers in 1918, with reports of dancing parties on the beach during the day and dance pavilions packed in the evening. Apparently, though, some visitors did not leave their bad habits at home

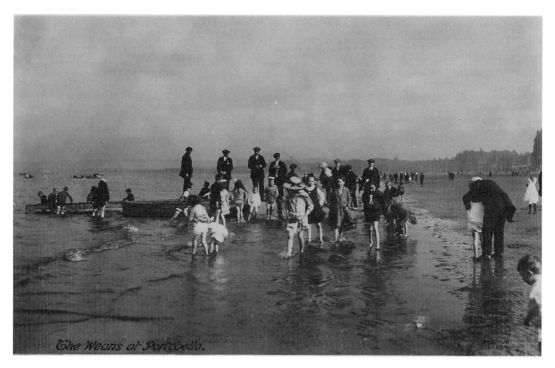

Weans and waders at Portobello.

for, among those who were sitting enjoying the sunshine or playing on the sands, there could be seen 'a large number of miners and manual workers engaged in card-playing and gambling'.

There may have been a darker side to all of this, however. On 31 July 1917, a Portobello miner was convicted of assaulting a tramway inspector and three lance-corporals a few nights previously. During his trial, it was stated that 'there had been a good deal of trouble, and a good many soldiers had been attacked on their way home at night, since the commencement of the Glasgow Fair holidays'. An Army officer giving evidence said that he knew personally of five or six attacks on men in his own battalion during that period. Feelings in the battalion were running so high that unless they came to an end, it would be impossible to prevent the men taking the law into their own hands when they were out. Later comment mentioned 'a chapter of ruffianism associated with the Glasgow holiday period', but care was taken to lay the blame on a distinct minority:

Of the behaviour of the Glasgow community who settled there [Portobello] for the Fair week, the police speak well. The circumstances of the assaults upon the soldiers … pointed to the operation of a gang or gangs of roughs, and are reminiscent of the epidemic in Glasgow some time ago, when street outrages were committed by bands with picturesque names.

The offence dealt with by the court had been committed by a local man and an accomplice from Musselburgh, and had nothing to do with the series of assaults noticed by the Army authorities. It was pointed out also that the attack was a random one, provoked by being put off a tramcar, and neither did it indicate any local ill-feeling or hostility against the soldiers stationed in the district. As far as can be judged by reading through the newspapers of the time, the citizens of Portobello remained on good terms throughout the war with the soldiers thrust into their midst. There are some reports of the kind of minor incident involving soldiers that one would expect in any garrison town, but no more than that, and there are others of actions that could only boost their image.

In one, Private Alex Mitchell of the Royal Scots showed initiative and quick thinking of an extremely high order. He was walking in the High Street when he saw a small boy, who was crossing the road, fall in front of an approaching tramcar. Realising that he could not reach the toddler in time to drag him clear, he grabbed a street cleaner's brush and swept the boy off the track with it. The driver of the tram was very quick to apply his brakes, but the front wheels came to rest on the spot where the child had fallen.

Two other reported incidents also involved the rescue of small boys who had got into danger. At the end of September 1917, Corporal Martin Lynch rescued Martin Murphy, who had been playing on the beach and was swept away by the tide. Corporal Lynch heard the child's cries, dived into the sea and, after swimming out to the boy, brought him ashore. The boy was unconscious but was brought round by Lynch and some of his friends using resuscitation techniques. A few weeks later, the Carnegie Hero Fund announced awards for Corporals George Gregory and William Painter, who had rescued a boy from drowning at Portobello on 10 August 1917, when they were both billeted at the Marine Gardens. They both swam out about 40 yards before reaching the boy and bringing him to the shore. They were each awarded an inscribed silver watch in recognition of their bravery.

Because of the fear of attack from the sea, or even invasion, Edinburgh, along with other local authorities on the Firth of Forth, began to impose lighting restrictions in its streets and on 2 October 1914, the *Edinburgh Citizen & Portobello Advertiser* reported that 'Portobello lights on the Promenade are to be discontinued on the instructions of the authorities'. At first the order applied only to public lights and did not include businesses or households, so it was rather stretching things to end with the statement, 'Thus we are all getting used to the privations of war.' However, the scope of the regulations was steadily widened and on 16 October it was said that:

> Darkness reigns on the Promenade now at nightfall. Not a light is to be seen and the windows looking out to sea are shaded by most people. We are living in unaccustomed experiences, but the sooner we learn to appreciate the danger of disobeying official instructions the better will it be for us.

One week later, the Seaside Jottings in the local newspaper summed up the situation in its customary pithy manner:

Portobello is now generally the worst lighted part of the City at night, but that we recognise is a necessity caused by the war.

*

None of us will grumble if that is the worst of the inconveniences caused us by the struggle.

*

Not only is the Promenade dark from end to end, but the side streets leading to it are equally devoid of light.

*

Anyone showing a light on the front will now render himself or herself liable to suspicion, for there are keen folks about, who see in the awry conditions of blinds evidences of evil intent.

The restrictions also applied to motor car headlights, and there were problems with this because the regulations were not applied uniformly by local authorities. Motorists coming into Portobello from East Lothian and Musselburgh could find themselves in trouble because the shading on their headlights did not comply with Edinburgh standards. They received some sympathy but, as this selection shows, residents of Portobello who did not heed the warning of the dangers of disobeying the official instructions could find themselves in the Sheriff Court. In May 1915, the owner of an ice cream parlour on the promenade was fined 10s for showing lights out to sea. This had happened on four separate nights during April, so his fine seems small compared to the one of £2 imposed on the occupier of No. 52 Bath Street for letting a light be seen from her premises after dark. A much more serious violation was committed by Wood's Bottleworks Ltd in August 1916. The manager of the works in Baileyfield Road pleaded guilty at Edinburgh Sheriff Court to the charge of not extinguishing all lights on the bottleworks' premises, because he allowed light to come from the three furnaces after dark. This was after receiving an order by telephone at 12.47 a.m., which was followed up verbally by a police constable at 1.10 a.m. The sheriff thought that this was a 'very serious and gross violation of the regulations' and that 'the conduct of the accused was exceedingly blameworthy' and imposed a fine of £15.

Public transport to and from Edinburgh became more and more unreliable and uncomfortable as the war went on. The chief culprit was the much despised and derided Edinburgh cable tramway system, but the railway also played its part in causing problems, inconvenience and triggering complaints. By its very nature, a cable tramway system is less efficient than one driven by electric power and requires a higher level of maintenance. It is more prone to breakdowns in normal conditions, but if maintenance levels are allowed to fall, failures will become more frequent and more serious. Edinburgh to Joppa was the longest journey on the system and, having the greatest length of cable, suffered most from failures. These mounted steadily from the start of the war and in one week in February 1916, there was a dislocation of the system of truly epic proportions. The stoppages were distributed over a number of routes, but *The Scotsman* reported on Saturday 19 February that 'the Portobello route has suffered severely'. Just how severely can be seen from the table below:

Sunday, 13th February
No cars running
Monday, 14th February
No cars running
Tuesday, 15th February
Cars running until 9.15 a.m.
Wednesday, 16th February
No cars after 2½ hours running
Thursday, 17th February
No cars running
Friday, 18th February
No cars running

According to *The Scotsman*, the service to Portobello was expected to restart that day and the tramway company hoped that the installation of a new cable 'will prevent the recurrence of any stoppage on this route in the future'. In fact, the trams did not start running again until the following day, Sunday, and even then crept along 'at a pedestrian pace, causing the loss of trains, failure of appointments, incalculable waste of time and a condition of fretfulness that may be imagined'. Of course, even with a new cable, breakdowns continued and the company claimed that it was impossible to properly maintain the system due to a massive loss of staff to the armed forces. This will be discussed in more detail in a later chapter.

To paraphrase a slogan from a later period, the train was not able to take the strain to help alleviate Portobello travellers' condition of fretfulness. The rail companies too were suffering from staff shortages and their resources had to be directed towards the war effort; passengers on short distance and suburban journeys suffered as a consequence. The *Edinburgh Citizen & Portobello Advertiser* had words to say on the situation on 5 January 1917, and they were by no means entirely sympathetic to the rail users:

People without imagination apparently dreamt that the cutting down of the railway facilities which they recently enjoyed would not entail much hardship. After nearly a week's experience they know better. The serious diminution of the service of trains has led to a great deal of heart burning.

The newspaper pointed out that the officials of the railway company were acting on government instructions and were powerless to change the arrangements. Passengers 'would have to grin and bear the consequences'.

It may help some of the people who are grumbling to get into a more acquiescent frame of mind to mention that at Portobello no fewer than 97 trains have been discontinued over the space of 16 hours. From that fact alone they can easily conclude why carriages are crowded, why trains move off without them in some cases, and why it would be better for them to make some other arrangements for travelling if they must do so by other than the natural mean of locomotion.

On one evening, a very large number of people could not get down to Portobello by train and, by ill-luck, this coincided with a breakdown of the tram service. While some managed to get taxis, others had to walk the 3–4 miles home. The conclusion reached was that the government wanted to reduce rail travel as much as possible and the evidence was that 'they could not have taken a better way of enforcing their wish'.

A large number of Portobello residents worked in Edinburgh. For them, a regular, reliable transport service was a necessity, given Portobello's distance from the city, and they did not get this during the war. Tramway failures and fewer trains did deter day trippers from Edinburgh, but not visitors from Glasgow, who had money to spend.

CHAPTER 3

KEEPING PEOPLE FED

Ensuring the food supply for a nation during conflict is difficult, without the added complication of living on an island, dependent on imports. Shortages compelled people to make the best use of the land available and reduce waste. With government support and propaganda, changes were made. Rationing, however, became necessary and continued after the end of the war until normal supplies were fully reinstated. Portobello was typical in the way its land and resources were managed to increase food production, and looking at the ways it was done reflects the situation throughout Britain.

At the beginning of the war, Britain imported 80 per cent of its wheat and 40 per cent of its meat, with the main exporters being America and Canada. Around 66 per cent of its sugar was imported from Germany and Austria as beet sugar. It is obvious, therefore, that the outbreak of war had a massive effect on the amount of food we were able to import, particularly sugar, and that controls would be needed to manage food supplies.

During the war, the government took increasing control of citizens' lives, industry and the economy. The original Defence of the Realm Act (DORA) was passed on 8 August 1914, and additions were made throughout the war. Other measures were passed, such as the British Summer Time Act, in May 1916, by which the clocks were put forward one hour to give more daylight for extra work.

The price of imported goods increased after the war began and by February 1915 flour prices had increased by 75 per cent; home-produced meat by 6 per cent and imported meat by 12 per cent; sugar by 72 per cent and coal by 15 per cent. Initially, the government did not want to intervene in a free market economy. Panic buying and hoarding of food by some people made life more difficult for others. Those on the lowest pay suffered the most and had poor diets as they were unable to afford the rapidly rising food prices. The dependents of men on active service struggled on their allowances, which were finally increased by October 1915. In November, a Food Controller was appointed. He called for voluntary rationing in February 1917, but with little effect.

Food imports did continue, but by the end of 1916 the German U-boat campaign was seriously affecting imports carried across the Atlantic on merchant ships. Around 300,000 tons of shipping were being destroyed a month. A sustained campaign of unrestricted submarine warfare continued and British dominance at sea was challenged.

The use of convoys helped reduce losses, but the increasing demands of the army for supplies meant that alternative sources of food had to be found. Fish catches were down as much of the North Sea was closed to fishing and many fishermen had enlisted or were conscripted.

Agricultural workers were also being called up, even though the government wanted the maximum amount of produce from the land available. Women substituted on the land as well as in factories. The amount of land under cultivation had to increase and, in 1917, the government took over 2.5 million acres of land for farming. Farmers were instructed on cultivation methods and if they did not obey, their farm could be given to another farmer. Much of the land in Scotland was used for hill farming and was unsuitable for arable use, so available land in urban areas was earmarked for food production. Town councils were put in charge of these and the number of allotments was increased. People were encouraged to grow their own, eat less and waste nothing.

Much of the rural, agricultural work was undertaken by the Women's Land Army. There was some resistance by farmers to employing more women and the Board of Trade began sending agricultural organising officers round the country to try to persuade farmers to do so. It is reported that by 1917, there were over 260,000 women employed as farm labourers. We have found no reports about Portobello farmers employing increased numbers of women, and in the next chapter, when we see farmers appealing against the conscription of their male workers, there is little evidence of additional women being targeted as substitute labour. Of course, some women already worked on farms, milking cows, making butter and looking after the poultry.

The Women's Forage Corps was set up in 1915 to provide food for the horses that were so important to the army. Women operated agricultural machinery, such as hay-balers. A Women's Forestry Corps had also been established to replace the men called up. The government seemed to feel some obligation to warn these female labourers about the standards they were expected to keep, stating, 'You are doing a man's work and so you are dressed rather like a man; but remember that because you wear a smock and trousers you should take care to behave like an English girl who expects chivalry and respect from everyone she meets'.

How events progressed and what land was used for food production in Portobello can be followed in reports from *The Scotsman* and the *Edinburgh Citizen & Portobello Advertiser*. A move to establish a 'Garden Allotments Movement in Portobello' was reported on 8 April 1916. A meeting had been held in Portobello the previous evening for 'gentlemen interested in the development of food production in war time by taking up garden allotments locally'. It was presided over by Mr H. J. W. Tillyard, a lecturer at Edinburgh University. Councillor Rose, Edinburgh, had found that, according to the Valuation Roll for 1915/16, there were 229 acres of vacant ground in Edinburgh suitable for vegetable production. He believed that these should be used as soon as possible. There was acreage available in Portobello and it was mentioned that 'responsible officials of the North British Railway Company had indicated a certain area of ground belonging to the company in Joppa district which would be available for the development of the scheme'.

On 2 May, 'a number of Edinburgh Town Councillors and other gentlemen paid a visit of inspection to the area in Joppa where a start has been well made with the local garden allotment movement to assist in food production in war time.' Mr Tillyard had taken up the first plot and 'showed the party the result of his labours.' His allotment measured 40 yards by 12 yards and was on the top of the railway embankment at Brunstane Road. His rent was 5s per annum. He had planted potatoes, onions and cabbages. He stated that the railway company were prepared to give similar plots on 'like terms.' Mr William Burt JP, secretary of the Gorgie Allotments Committee, who was also present, viewed the site favourably and 'compared the Joppa rate of 480 square yards for five shillings with the Gorgie rate of 13s 4d, including water rate and taxes, for 200 square yards'. Those in attendance were informed 'that Edinburgh Corporation were prepared to supply manure at the low rate of 2s per cart'. All hoped the movement would be a success and that the three councillors representing Portobello Ward would encourage the growth of the movement. Whether this group became part of the Portobello Allotments Association is not clear.

Parks and golf courses in various parts of Edinburgh, including Portobello Park, were to be used for food production. On 23 January 1917, it was reported that a meeting had been held in Portobello Municipal Buildings presided over by ex-Baillie Adams. The head city gardener, Mr McHattie, stated that there were over 20 acres of ground in Portobello suitable for cultivation. On the motion of the Chair, an Allotments Association for Portobello was formed, with Councillor Carmichael as President and Mr T. Gray as Secretary and Treasurer.

Later that month, it was reported:

a farmer had undertaken to break up 45 acres of Niddrie policy parks, which adjoin his farm. An effort is being made to have other policy parks, and also parts of golf courses, including those at Portobello and Saughton, put under the plough. The difficulty in some of these cases is not so much to get labour, but horses and ploughs. It is hoped, however, to overcome this difficulty to some extent by receiving assistance from the farmers in the neighbourhood.

The Lord Provost's and Public Parks Committees were presented, on 1 February, with a joint report from Mr John Gibson, Chief Inspector of the Cleansing Department, and Mr McHattie, Superintendent of Parks, who had surveyed the extent to which golf courses might be made available for cultivation. Public parks and recreation grounds covered an area of 680 acres, with only 14 acres unable to be cultivated. They reported that there were 55.24 acres at Portobello Park, but that they could not be cultivated profitably. It was exceptionally good turf and the usual revenue, including grazing, was £400. If the turf was broken up, its use to the public would be lost for probably four years. However, Mr Simpson, a farmer at Duddingston Mains, had agreed to plough, sow and reap Portobello Park as long as he got help from Edinburgh Corporation. These arrangements were approved by the Committee, who recommended their adoption to the Town Council.

Mark T. Simpson, of Duddingston Mains Farm, was having great difficulty keeping his male workers, who were being conscripted for military service. It seems rather

peculiar, therefore, that he would offer to take on even more work. He had submitted several appeals for one of his ploughmen, a certified occupation, between August and December 1916, before he was finally given an exemption 'on condition of man remaining in his present employment'. His appeals are looked at in more detail in the next chapter.

The demands to expand food production took place at the same time as the need for men for military service grew. Horses were being requisitioned for service at the front, with many farmers losing, for example, three of the four horses they had. It is to be wondered how production was expected to increase when the labour, human and animal, was being drastically reduced.

The plans to use Portobello Park continued to be reported in February:

Harrison Park, leased by the city, to be used for allotments. Applications were received from the Portobello Association and from another association at Saughton asking that ground at the Portobello Park and Saughton Park be set apart for allotments. As has already been stated, there is a different proposal regarding Portobello Park, and it was agreed to delay dealing with the Saughton Park till investigation was made as to the number of applications.

A report on a meeting of Portobello Allotment Association noted,

It is gratifying to know that the recently formed Allotment Association in Portobello has got right into harness and that it is anticipated there will be a number of allotments obtained in the district. All the vacant land in the neighbourhood which it was thought might be turned to the useful purpose of food growing is not entirely suitable and other parts are not likely to be got because of restrictive prices. It was decidedly understood in the district that if sufficient land was not obtained for members, there might be a chance of breaking up a bit of the Public Park, but, now it appears as if the ground there, if turned to food growing purposes, would be put in charge of a farmer to work. This would, of course, be a disappointment to the Association workers, but we have no doubt they will readily understand the point of view of the board of agriculture, which is that the most efficient method of raising crops be adopted provided the labour can be supplied. If the farmer can get hands then it is possible the attainment of the object – food growing – could best be achieved by his work upon the land rather than by the labours of individual holders.

By 15 February, 'arrangements [had] now been made with the neighbouring farmers for the ploughing and cultivation of the portion of the Braid Hills Golf Course which is to be broken up, and also those parts of Saughton Park and Portobello Park that are to be cultivated'. The following day it was reported that Edinburgh Council had decided to reserve 5 acres of Portobello Park for use by the military; 3 acres were to be set aside for allotments with the remaining 40 acres to be put under the plough.

The Public Parks Committee had made arrangements for using the greenhouses in public parks to cultivate plants for allotment holders. It was also agreed that a depot

should be established in the Public Parks Department to supply seeds, plants and tools to allotment holders. The depot was to be at Hope Park Hall.

A meeting of the Allotment Association was held on 21 February, where it was reported that the 3 acres of the ground in Portobello Public Park assigned by Edinburgh Town Council for allotments had been fully applied for. A ballot was held to allocate the plots to the seventy applicants. It was further reported that the council had another half-acre in the park that they were prepared to assign if there were further applications for allotments. The enthusiasm of allotment holders is shown in a report of 28 February, noting a request by them to be allowed to work on their allotments on Sundays, although the regulations prohibited this. The Public Parks Committee were asked to make a decision on this and stated that they would not interfere with the regulations even though these were exceptional circumstances, but that they 'would not impose undue restrictions on those who worked on Sunday'. The Lord Provost said that the council's position was that 'individual allotment holders were left to decide according to their own individual conscience and judgement'. A discussion followed on the cultivation of land in the public parks, including Portobello. The farmers ploughing the land paid a rent between 30s and 60s per acre. 'This was a business proposition the Corporation were likely to come well out of, and it was evident that the farmers, on their side, knew quite well what they were going into.' Although the land was being used to comply with the national demand for increased food production, the council still saw it as an opportunity to make a profit.

An advertisement was placed in the *Edinburgh Citizen & Portobello Advertiser* on 23 February, giving notice to the public that

The Corporation have arranged that certain portions of the Public Parks are to be cultivated for the production of food in present circumstances, and notice is hereby given that on and after Saturday, 24th current, the following Parks will, until further notice, be closed to the public to the extent after mentioned, viz: (1) Portobello Park, the whole Park; (2) Braid Hill Golf Course, Section from Liberton Towers to Winchester's known as 'new ground'; and (3) Saughton Park, area known as Recreation Ground.

On the same day the Edinburgh School Board placed an advertisement for

Lectures to Allotment Holders
A Course of Eight Lectures
for Allotment holders and others interested in
Practical Gardening; on Garden Management,
Methods of Soil Working and Manuring,
Vegetable Growing etc., will be given in
Portobello Higher Grade School
On Thursdays, from 8 to 9.30
Beginning 1st March
Fee for Course 1s
Teacher – Mr George Stuart, College of Agriculture

There was opposition to ploughing up the parkland. At a meeting of the Governors of Edinburgh and East of Scotland College of Agriculture on 28 February, Mr W. M. Price commented that

> He thought it was a great mistake. He did not wish to belittle the cry that our food supply was in danger, and if there was no other ground available he would plough up Princes Street Gardens. But there was other ground available, and to plough up the city parks would be a waste of energy. The 120 acres of ground were to be cropped by farmers who would have to come from the outside, and it was a question whether their time would not be better taken up on their own farms. If the city wanted to help they might have given the farmers a similar acreage outside, and given them a preference for grazing in the city. The worst feature was that they would be doing away with the open spaces which were the lungs of the city and the playgrounds of the children, and which would be required for the recuperation of wounded soldiers.
>
> Councillor Richardson said there was no proposal to tear up the city parks generally. No one had suggested interfering with the Meadows or any park of the city except Portobello Park. Councillor Rusk also supported the action of the Town Council. The discussion then concluded.

A list of 'Seaside Jottings' was printed in the *Edinburgh Citizen & Portobello Advertiser* on 9 March 1917. After various comments on the bitterly cold, snowy weather, these followed:

> The allotment holders have now got 'settled upon the land' – in the Portobello Park.
>
> *
>
> They got turned to on Saturday last, which was an ideal day for gardening, and got a bit of ground dug up.
>
> *
>
> Sunday was a fiercely cold day, and those who procrastinated, intending to take advantage to the day of rest for labour, were a bit disappointed.
>
> *
>
> It was by no means genial to work in the open, whereas on Saturday an hour or two's digging was a healthful and enjoyable recreation.
>
> *
>
> Now that Portobello Park is being turned to agricultural uses, a few grumbles, more in sadness than anger, are heard.
>
> *
>
> The fact is the people are recognising that sacrifices have to be made, and an hour or two of occasional golf can be readily yielded up to the benefits of food growing.
>
> *
>
> Besides, those who must golf to exist will still find some courses open to them.
>
> *

A rather eminent Professor of the University suddenly awakened to the fact that Portobello Park had been disposed of, held commune with the local representatives on the matter, but found that he was too late to intervene.

*

His contention was that such a park should not have been incorporated in any scheme of food raising as it would be spoilt for years.

*

But that is just one of the sacrifices the citizens are so readily making now.

*

And possibly the present-day ratepayer argues the matter to himself in this wise.

*

Better to run the risk of spoiling the park for a few years for pleasure than help the Germans to starve us.

The push to increase food production was backed up by government propaganda. This advertisement and the following article appeared in March 1917. The advertisement was headed 'Our Food stocks are low – alarmingly lower than they have been within recollection'; it continues,

Every time you buy food in a shop or eat it at table say to yourself that our merchant sailors have died and are dying to bring it to you.

If you can use a spade, if you are good at gardening – go on the land at once. Go to help replenish our dangerously low stock. *Go now while there is still time for the spring sowings to yield you summer and winter food. In a few weeks it will be too late.*

It is essential for the safety of the Nation, for the maintenance of the Nation, for the life of the Nation, that we should put forth immediately every effort to increase production for this year's harvest and the next. Mr Lloyd George.

There is further encouragement:

Men, country born and country bred, now engaged in the cities; amateur gardeners, professional gardeners, flower growers, brickyard hands, livery stablemen, road menders, water-pipe layers, golf club employees, outdoor servants, gamekeepers, hedgers and ditchers, and, above all, ex-ploughmen and men who have worked on the land – OFFER YOUR SERVICES during these critical months.

Lloyd George exhorts, 'The farmer could increase even now by hundreds of thousands of tons the food of this country this year. One of the main obstacles is lack of labour'. The government itself had exacerbated the labour shortage when it introduced conscription. There is no encouragement here for women to rise to the cause and offer their services.

The article on *Food, And How To Save It* was written by E. I. Spriggs MD FRCP at the request of the Food Controller. We may think we are calorie conscious now, but

this article explains the calories, carbohydrates and fat needed and how to maintain a healthy diet. Spriggs details,

> We are called upon at the present time to save both bread and potatoes. These two foods owe the greater part of their food value to starch. Starch, like sugar, belongs to the class of food stuffs called carbohydrate, which is the main source of the heat and power of our bodies, supplying, as it does, more than half the energy of an ordinary diet. Every ounce gives 116 calories.

He gives a list of foods which supply carbohydrate, with those containing the most first:

Sugar	98 per cent
Tapioca, Sage, Arrowroot	85 per cent
Rice	79 per cent
Barley Meal	73 per cent
Maize	66 per cent
Oatmeal, Beans, Peas and Lentils (Dried) and Dried Fruits	60 per cent
Bread	57 per cent
Treacle	55 per cent
Potatoes	21 per cent
Green Peas and Beans	17 per cent
Bananas	14 per cent
Fresh Fruit	12 per cent
Milk and Nuts	5 per cent

He advised that bread, flour, potatoes and sugar were the most valuable foods, but that rice, oatmeal, dried peas, beans, fruits and milk also supplied 'energy-giving starch'. He continued:

> If oatmeal porridge is on every breakfast table, the amount of bread eaten at that meal will be much lessened. Oatcake should also be eaten at tea-time. Boiled rice, haricot beans, and pearl barley, served as vegetables or cooked in stews, will take the place of part or all of the bread and potato formerly eaten at dinner: and in milk puddings made with rice or the 'corn' flour of maize and in preserved fruits we have nutritious foods. Sugar should be saved by taking none in tea or coffee, so that the whole allowance may be used in cooking to make other foods nice.

He declared it urgent that those in 'comfortable circumstances or sedentary occupations' save bread and flour. If workers were to work with vigour, they needed a good supply of carbohydrates. He believed that many labourers had been underfed, leading to a 'lack of go'. He described fat as an important source of energy as 'its fuel value is more than twice as great as that of protein or starch', declaring that 'an ounce of it gives 264 calories'.

He gave a list of foods which provided fat – the highest amount first:

Lard	95 per cent
Butter	85 per cent
Margarine	84 per cent
Suet	82 per cent
Bacon	60 per cent
Pork	40 per cent
Cheese	30 per cent
Mutton	25 per cent
Nuts	22 per cent
Beef	20 per cent
Eggs and salmon	9 per cent
Herrings and Milk	4 per cent

He wrote that butter, margarine, bacon and other meat, cheese and milk supply the bulk of the fat in our food. He believed that fat could replace carbohydrate and suggested that 'the well to do may help those who are less fortunate by taking plenty of such food as butter, eggs and salmon, so as to need less bread and potatoes' and that 'cheese should be restored to its old place as a staple food for all classes'. He suggested a particular diet for children, as they needed:

a good deal of fat, which can be best given to them as margarine and in milk. In schools every effort should be made to balance any saving of flour and meat by an increased amount of other foods and especially of milk. One pint of milk is equal in food value to four ounces of flour or over five ounces of bread or beef.

When making these suggestions, Spriggs was encouraging voluntary rationing and food control. By the end of 1917 rationing would become compulsory.

There was little need to encourage people to cut down on their consumption of potatoes given the reports of potato shortages. Apparently some people had been complaining that they had not seen a potato for weeks. There was comment that increasing numbers of children were seen travelling on the trams from Piershill to Joppa, carrying baskets of potatoes for sale.

Efforts to produce more continued, with the Scottish Motor Traction Company offering the Parks Committee the use of a tractor with a driver and a man to help with ploughing for either fourteen days or three weeks, on the condition that this should be used 'for the benefit of the city'. The offer was accepted and ploughing was expected to start immediately, probably 'for the considerable tracts of ground which are being put under cultivation in Saughton Park, Portobello Park and at the Braid Hills'. Initially it was not to be used for ground that had already been divided into allotments.

An exhibition by Edinburgh and Leith Garden Allotments was held in August. There were two prize-winners from the allotments in Portobello Park: J. Brockie, No. 8 Mentone Avenue, was second and A. S. Lemon, No. 4 Hope Street, was third.

Mrs Richardson, No. 12 Wellington Street, won a silver medal for the best crop of potatoes. An exhibition of allotment produce was to be held in the Synod Hall at the end of September and was expected to provide 'evidence of what can be done towards increasing food production in a space of time considerably less than nine months – in some cases the ground was not broken until this year was well advanced'.

There are no further reports for 1917, with the first on allotments given at the beginning of 1918, at the first AGM of Portobello Allotments Association, which was held in the Court Room. The finances were 'satisfactory' with a credit balance of 10s 3½d. Rentals paid to the council amounted to £39 5s £3 was paid to Mr Torrance for allotments at Mount Lodge. Four public, two general and eleven committee meetings had been held throughout the year. There were sixty-two allotments which had been marked off with the names and numbers of the holder on either side of the pegs marking the area. It was believed that this 'should afford an early start to those desirous of outshining the old brigade'! The Town Clerk had advised the secretary that last year's allotment holders did not require to sign new missives. The association was negotiating for additional ground for allotments and, if successful, would be able to offer twenty more plots in convenient positions, with those requesting a plot to hand in their names. Office-bearers were elected, with the chair, Councillor Carmichael, and secretary, Mr T. Gray, re-elected. Questions were invited and one member asked if it was against the rules to breed rabbits on your allotment. It was stated that the council would not permit this and that they would not allow poultry keeping either. It was agreed to have a local show of allotments, allowing members to display their produce. Councillor Hastie, honorary vice-president, offered the rent of two allotments as prizes. There is no mention of the type of produce or the amount produced over the year and it seems rather peculiar that allotment rentals could be offered as prizes when plots were in such short supply.

The number of allotment holders in Edinburgh had increased from three to four thousand and the depot established to supply them was reported to be a success. They had learned a lot in the past twelve months and the depot was open on weekdays, until the end of March, to supply their needs. In the few months the depot had been open the previous year, over £1,000 worth of goods had been sold at cost price. These included seeds, plants, manure, fertilisers and tools. Better quality was expected this year as there was more time to select the goods for sale. The best seed potatoes had been obtained from Perthshire, Forfarshire and Dumfriesshire.

There were more 'jottings' in February, which provide various snippets of information about the AGM. It was reported that Portobello Allotment Association held ballots for sixty new allotments as there were sufficient members wanting to take them up. More allotments were needed as applications had been received from Jewel Cottage miners. Mrs Wauchope, of Niddrie Marischal, was to be approached for ground on behalf of the miners, but that had to be done through the Local Authority for Liberton parish. Ratepayers were to have first option for allotments. Local Authorities now had considerable powers to commandeer vacant ground for allotments, but apparently Edinburgh had no difficulty in entering into friendly relations with proprietors. The allotment movement was voted to be a great success and was expected to continue to expand.

In August, Miss Proven, No. 4 Hope Street, and Mr D. Blyth, No. 6 Rosefield Avenue, won the Ladies and Gents prizes awarded by Portobello Parks Committee for the best allotments. Each was presented with a silver medal. There was an exhibition of potatoes and vegetables at the Synod Hall, Edinburgh, at which 'all the good things that are spread on the tables have been grown on public ground – at Saughton, Portobello and Inverleith.' Lord Provost Sir J. Lorne MacLeod, who opened the exhibition, declared that 'he thought the cultivation of the land was the finest form of recreation they could have, alike as regards its productive, educative and moral values'.

Land was returned to pre-war usage very quickly after the end of the war. On 29 November 1918, it was reported that the Parks Committee of Edinburgh Town Council had decided to give notice to tenants holding ground at the Braid Hills, Saughton Park and Portobello Park and that they would resume occupation at Martinmas (11 November) next year for the purpose of restoring it for public recreation. By 4 December, it had been agreed that the same notice would be given to farmers presently leasing ground for cultivation at the same sites. If by then it was still necessary to produce food, then 'the Committee could relax their proposals'.

Although the reports on allotments paint a positive picture, there is no indication what effect they had on the availability of food locally. Presumably the food allotment holders produced would be for their own consumption, putting them in the fortunate position of having an additional food supply. We have no record of what was grown in Portobello Park or how much was produced. We do not know how many other additional acres farmers cultivated in the Portobello area, although we do know that supplying the labour to work the land was problematic. Whatever the amount of additional food was, it was insufficient to meet demand.

People tried any methods at their disposal to ensure an adequate supply of food. An increase in the membership of Portobello Co-operative Society was reported at the half-yearly general meeting in May 1917, with an additional 253 members since the beginning of the war. With sugar supplies now less than half of pre-war amounts, this increase in membership put an added strain on provisions. All branches of the co-op showed increased sales, with average weekly sales in the butchery department of £173 and £301 in the bakery, which baked sixty-six bags of flour weekly. The grocery department had a turnover of £16,000 for the previous six months, giving an average of £619 per week. It was stated that the shortage of foodstuffs, such as potatoes and Danish butter, was causing members anxiety and disappointment, but that there were hopes of more regular supplies in the future.

Maintaining food stocks was a continual struggle. In spring 1917, it was reported that there were food stocks for three weeks in Britain. By April, one in four merchant ships was being sunk by U-boats. The government continued to urge thrift and there were reports that some of the poorest were suffering from malnutrition. The rises in food prices and rent eroded much of the growth of wages. Coal, used for cooking and heating, was in short supply.

In September 1917, a meat retail price control was introduced, along with a flour subsidy to bring down the price of bread. A potato subsidy was brought in in November. There were long queues at shops, often controlled by policemen. Sugar, potatoes and

margarine were in short supply, with butter often unobtainable. By the end of 1917, people began to fear that food would run out, leading to panic buying of whatever was available, which caused further shortages. There were continuing signs of malnutrition in the poorer communities. As a result, the Ministry of Food decided to introduce rationing in January 1918.

The first commodity to be rationed was sugar, which was rationed until November 1920. Other foodstuff quickly followed – raw meat was rationed from April 1918 until December 1919; bacon and ham from April 1918 until July 1918; butter from July 1918 until May 1920; margarine from July 1918 until February 1919; lard and tea from July 1918 until December 1918; and jam from November 1918 until April 1919.

Portobello residents were subject to the same food controls as elsewhere in the country. Ration cards were issued and each household had to register with a butcher and grocer. Each house had three ration cards: one for butter and margarine; one for meat; and one for sugar. Each adult was allowed 15 ounces of beef, lamb, mutton or pork; 5 ounces of bacon; 4 ounces of butter, margarine or lard and 8 ounces of sugar per week until rationing ended and if the goods were available. Meatless days were introduced but these did not seem to be successful.

Some shops sold goods without checking ration cards. According to *The Scotsman* on 14 May 1918, 'William James Hunter, butcher, 228 High Street, Portobello, was fined £1 at Edinburgh Sheriff Court yesterday for selling to a Food Control Inspector, on 22nd April, 1lb. of sausages without obtaining from him the requisite coupons.'

In his *War Memoirs*, Lloyd George wrote that rationing ensured a regular and sufficient supply of food and allowed more precise calculations to be made on how to fairly divide the available food stocks. Rations were adjusted according to supply. In general, people's health improved as a result of rationing, as the supply of food was regulated and assured, ensuring some with a food supply not previously available. He noted, 'Although there was a degree of scarcity, we were never faced with famine or actual privation.' He believed that 'without general goodwill it would have been impossible to make the regulations effective'. It has also been suggested that for many working in factories the food supplied in factory canteens provided a better diet than normal.

The same has been said about military rations, with many servicemen from poorer families receiving better food than they were used to, but getting food to the front line was often a problem. The British Army employed around 300,000 fieldworkers to cook and supply food, with the challenge being to make sure the food was in good condition when it reached soldiers. The size of the Army grew and blockades restricted the amount of food reaching the front. As a result, rations were cut, particularly meat rations. Much of the soldiers' food began to be supplied in tins; particularly bully-beef (tinned corned beef). This was supplemented with bread and biscuits, although if flour was in short supply, bread could be made with ground turnips. Food was often cold by the time soldiers received it, particularly if a battle was raging, and they would boil everything together in their mess tins to heat it up. A soldier's emergency ration tin could only be eaten with permission from an officer. It contained cocoa paste and beef paste, which could either be spread onto hard biscuits or mixed with boiled water

and drunk. Iron rations were often carried by soldiers when advancing into enemy territory. Troops in the front line were always complaining of hunger, with troops out of the line much better fed.

After the war ended, rationing of some food continued, as described above, but there is a report that 'The right to make cakes and pastries of every kind and to cover them with sugar or chocolate or both was restored to Britons on 7 December, 1918, as was the right to eat an unlimited quantity of these or other cakes at afternoon tea.' A double meat ration was allowed for Christmas 1918.

In the United Kingdom, rationing controlled the distribution of food more equitably, ensuring noone starved during the war. It was not the same in mainland Europe. Allied blockades affected Germany, with Berliners the first to be issued with ration cards in 1915. The potato harvest was a disaster in 1916/17, with turnips and beets becoming staple food. Many Berliners depended on soup kitchens for nourishment. The Russian advance in 1914 had a similar effect on Austria-Hungary. Riots and revolts were triggered by the food crisis. By 1917, Hungarian grain was feeding the Army, while the civilian population in the Austrian part were starving.

Even though the government delayed introducing rationing for as long as possible, it did finally ensure that there was a fairer system of food distribution. How much difference the produce from allotments made is unrecorded. The push to use all available land for food production needed a larger workforce. Some of these were women. The need for skilled, male, agricultural workers competed with the demand for male conscripts. How farmers and other food producers challenged the demands of the military is illustrated in the following chapter.

CHAPTER 4

CONSCRIPTION & TRIBUNALS

The initial enthusiasm for war started to wane during 1915, as information about the increasing number of casualties and conditions at the front became more widely known. The number of recruits began to fall, with fewer wanting to go to 'the hell where youth and laughter go' (*Suicide in the Trenches* by Siegfried Sassoon). How to encourage men to enlist became a major focus of the government.

Britain was the only major European power not to have conscription, as it was deemed politically unacceptable. Initially, voluntary schemes were used to recruit men for military service. The National Registration Act of July 1915, required all men and women between the ages of fifteen and sixty-five to provide details of their age, occupation and marital status so that the government could calculate the number of men eligible for service. A list of occupations of National Importance was drawn up, which included agriculture, food supply, shipping, transport, mining, education, and public utilities services. Men employed in these occupations were not to be enlisted in the Army. This will be relevant later in this chapter. The details of all registered men between eighteen and forty-one were passed to the military authorities to be used for recruitment purposes.

In 1915, the Derby Scheme of attestation was instituted but this failed to raise the increasing numbers of men required. As a result, Britain introduced conscription for the first time. The Military Service Act of January 1916, introduced conscription for single men and childless widowers between eighteen and forty-one. In May this was extended to include married men and the upper age was raised to fifty. As more men left, farmers and businesses struggled to cope. Local services suffered as tradesmen were difficult to find.

Men could apply for exemptions from service and employers could apply on behalf of their employees, but there was no guarantee of success. A man, called the appellant, could apply to his Local Tribunal for exemption from service. Local Tribunal committees were made up of what are often described as 'local worthies', with few women all over the age of military service. There was also a military representative who could object to any application for exemption. Exemptions could be absolute, conditional or temporary. The first tribunals were held in March 1916 and continued until 1918. There were about 157 tribunal cases recorded for the Portobello area, with some appellants having multiple hearings. These records are available in the National Records of Scotland (NRS) at Register House.

If his application was refused, the appellant could appeal the decision by filling in a Notice of Appeal, which had to be submitted 'not later than three clear days after

the decision of the Tribunal'. If this appeal failed, an application could be made to the Central Tribunal but 'only by leave of the Appeal Tribunal'. This would not always be given. Although the categories for exemption were clearly defined, the decisions taken could be inconsistent and apparently illogical, with examples given here showing that ploughmen and dairy men, engaged in work in the national interest and particularly in food production, were refused exemptions, while a bank teller and brewery manager had their appeals allowed. These case studies show the effect the shortage of men had on local services and businesses. Names have been omitted because of the condemnation often directed at appellants.

Agricultural workers should have been exempt from military service, but as the war continued more were called up and their employers must have spent a lot of time applying for exemptions and on appeals. As already described, Mark T. Simpson, Duddingston Mains Farm and Meadowfield Farm, agreed to plough, sow and reap Portobello Park, although he had problems finding enough men to meet his existing needs. Two of his men had already been granted conditional exemptions when he submitted several applications and appeals for his foreman ploughman between August and December 1916. The man was finally given a Certificate of Exemption 'on condition of his remaining in his present employment'.

The Tribunal gave their reasons for refusing the initial application as:

> The applicant has two farms near Portobello; the acreage being 300 acres of arable land and 145 acres under green crop. He has 13 men and 5 women and eight pairs of horses. The man applied for was formerly byreman. The applicant also applied for the exemption of two other employees and the Local Tribunal exempted both men on condition on their remaining in their present occupation. As regards the subject of the present appeal, the Local Tribunal were of opinion that although the man is engaged in a certified occupation, it was not in the National interests that he should be retained in his present employment, as, in their view, the remaining staff is sufficient to cope with the work.

It is worth noting that Simpson still had sixteen horses, given the number of horses that were requisitioned for military use. The phrase 'not in the National interests' is one that was frequently used when refusing exemption applications. Simpson appealed this refusal on the grounds that

> — is the only foreman ploughman on the farm of Duddingston, and is the only man with sufficient experience for that work. The farm work is very far behind, and in view of the approach of hay and harvest times, and the early potato lifting being in progress, it seems impossible to dispense with his services.

A lengthy report was prepared by the Board of Agriculture, detailing the land worked, stockage and labour on Simpson's farms. On his farms Simpson employed five men of military age, including one 'rejected for Army on medical grounds' and two with conditional exemptions; eight over military age; two youths under military age; and twelve women. He had also employed 'a number of unskilled Irish workers for the

Potato-lifting – 57 women and girls and 14 males, of whom 8 are believed to be under military age.' It commented that 'the man applied for, is in addition to being a ploughman an expert stacker and can do practically any kind of work on a farm. He has been with Mr Simpson all his working life.' The Board closed their report by stating, 'The Board are not prepared to say that the combined staffs of the two farms could not afford to lose one man but this man being foreman ploughman is of more use to the farm than the young ploughman on Duddingston Mains and the Board submit that the case should be considered on that footing.' Whether or not this influenced the final decision to grant a conditional exemption is impossible to say.

Simpson intended to employ a ploughman who was transferring from Mr J. R. Gray of Niddrie Mains. This man already had a conditional exemption, but it appears that it was not possible to automatically transfer this to another employer and his exemption was withdrawn. Simpson applied for an exemption, which was refused, and then appealed, but eventually informed the tribunal that he had managed to get an older man and 'therefore so far as I am concerned my grounds of appeal are gone'.

As it proved so difficult for Simpson to gain exemptions for his male workers, one wonders why he took on the extra work with Portobello Park. He never mentioned this extra work in any of his statements on exemption or in appeal applications.

Ploughing in a field at Duddingston Mains Farm. The view is towards Arthur's Seat.

William Douglas, a market gardener at Easter Duddingston, Joppa, struggled to keep the men he employed. His foreman applied for an exemption on various grounds:

1) An exempt occupation
2) As my mother will have no means of support, as it takes 15/- to 16/- per week for rent coal and light
3) The reserved Occupation Committee considers that any firm growing vegetables seeds and agricultural seeds should receive special consideration from the Local Tribunal
4) Conscientious objection to military service

His application was dismissed for the following reasons:

> The applicant is a foreman Market Gardener employed with Wm. Douglas, Easter Duddingston, Portobello. He entered his present employment subsequent to the passing of the Military Service Act 1916. He was previously a Gardener on a Peebleshire estate belonging to a Glasgow gentleman. His wages are 27/- shillings weekly. His mother (age 66) resides in Glasgow with his brother. The applicant gives pecuniary assistance to his mother but could not state a definite sum. He further stated he had a conscientious objection to combatant service.
>
> After consideration, the Local Tribunal were of the opinion that, although the applicant might be held to be in a certified occupation it was not in the national interests that he should be continued in his present employment, and that there would be no serious hardship in the event of his joining the colours. Further they were not satisfied that he had a conscientious objection to combatant service. (Note – An application by the employer was also dismissed by the Local Tribunal.)

Here we can see how much evidence and proof was required by tribunals before any decision was made. The applicant's conscientious objection seems to have been dismissed out of hand. Douglas appealed the decision and applied for a conditional exemption as long as his foreman remained in his present occupation:

> I have been doing my best to obtain a foreman in advertising and other ways and am doing so still but up to the present I have not been able to secure one. My reasons for making this appeal are purely on the grounds that I would be in an utterly impossible position to carry on anything like the same extent the production of vegetables without the assistance of —, he is an experienced & skilled foreman and takes full charge of all the works in my gardens during my absence & at other times. I am at present very short of men and very far behind with my work and I am quite aware of the fact that at present I could not substitute him. My gardens extend to 24 acres & the vegetables produced are for the most part used as food in the city of Edinburgh.

His appeal was dismissed. He had more success with his application for a man he employed as a ploughman and market gardener. This man was granted a conditional exemption until 1 May 1917 and Douglas applied for another conditional exemption on

10 May. Among the reasons given for his appeal was that 'I have entered into contracts with the Army Canteen Supply Committee to supply large quantities of vegetables during the year. The possibility of carrying out these contracts will be almost out of the question if — is taken from me just now.' A document from the Board of Agriculture detailed:

> At the census scrutiny the staffing of this farm was only considered to be 'Sufficient' by the Board's representative and the Military representative. The Board understand that the staffing of the farm has been reduced by one man and that the market gardener is obtaining casual assistance from two soldiers to meet this deficiency. In these circumstances the Board recommend that the man be granted exemption.

A Certificate of Exemption was granted to the man 'on Condition of his remaining in his present occupation'. Presumably, some consideration had been given to the Board of Agriculture's report and the fact that the market garden was under-manned.

A pig breeder and dairy farmer applied for an exemption for his son who worked with him and was needed to help carry on the business. His was eighteen years and nine months old. The farmer gave a detailed list of the duties undertaken by his son and that he had five other employees 'one of whom attested, but who was rejected twice. The remaining four are also physically defective, and not reliable, but, owing to the scarcity of labour good workmen cannot be obtained.' He had military contracts and supplied the Royal Fusiliers camps, Marine Gardens, Chocolate Works and the KOSB camp at Duddingston House.

The Local Tribunal gave their reasons for refusing an exemption as follows:

1) That the Applicant has five other men, who with the Applicant himself, should be sufficient to carry on the Applicant's business of pig breeder and pig feeder, the dairy business having now been given up.
2) That it should not be impossible for the Applicant to make arrangements for the conduct of his business in the event of his son joining H. M. Forces.
3) That it is more expedient in the national interests that the Applicant's son should be employed in military service than be engaged in his present occupation.

The appeal was dismissed.

A dairyman with Peter Shaw was granted an exemption 'conditional on his remaining in his present employment', but the Military Representative appealed against this. He gave several reasons including, 'In my opinion the business could be carried on without him and in view of the urgent needs of the army he would be of more use to the nation as a soldier than in civil employment.' The appeal was sustained and the Local Tribunal was told to withdraw the Certificate of Exemption granted by them.

James Gibson, dairy farmer, applied for an exemption in August 1916 for a twenty-one-year-old employee stating:

> Having 25 cows, horse and pigs and having to drive milk to Edinburgh twice daily it is impossible for me to manage myself. I have advertised in Scotsman and done my

very best to get a man and have never got even one applicant and it is impossible for me to get help in any way as all the men seem on Military Service and would be glad if it were possible to get him Absolute Exemption.

His application was refused on the grounds that 'The Tribunal considered that the Appellant could with the assistance of women carry on his dairy business without this man.' His appeal was also refused, with both the Appeal Tribunal and the Military Representative stating that there were not sufficient grounds to justify exemption.

It seems that what qualified as being in the national interest changed as the war dragged on, and the huge number of men lost led to an ever-increasing demand for replacements for the front. Irrespective of the necessity to maintain and increase food production, the demands of the military took precedence. Another act passed at the beginning of 1918 removed even more men from agricultural labour. It allowed the government to quash all exemptions on occupational grounds and raised the age of compulsory military service to fifty-one years. How producers were meant to feed the nation, both at home and at the front, with a shrinking labour force was not explained. Farmers were using female labour but women were also in increasing demand elsewhere.

Other industries and businesses struggled to maintain their production and provide services. Two local factories were greatly affected by the loss of male workers, initially with those volunteering, with one breaking the law trying to keep production going. Richard Cooper & Co. Ltd, Forth Bottleworks, made eleven appeals, eight of which were successful. Wood's Bottleworks Ltd made seven appeals, with two successful. In an appeal for a glass blower, dated 10 July 1916, Cooper stated that 'The trade is one of the reserved occupations and with the present shortage of labour the man is irreplaceable. Under these circumstances we ask exemption so long as he remains at his present occupation.' In refusing the application, the Local Tribunal decision stated,

> The pre-War staff of blowers was 107 of whom 71 were of Military age and of these 50 enlisted. The present staff of blowers is 78, of whom 30 are of military age. The principal manufacture at present is mineral water bottles. After consideration, the Local Tribunal were of opinion that although the man applied for is in certified occupation, it was not in the National interests that he should be retained in his present employment.

Wood's tried to resolve their staffing problems by employing under-age child labour and ended up in court as a result. In February 1915, the directors of Wood's pleaded guilty to employing child labour, namely two boys living in King's Road. They were working full time, alternate weeks on day shift and night shift. During day shifts they did not attend school. During night shifts they went to school at 8 a.m. until 3.30 p.m. and then went to the bottleworks from 6 p.m. until 5 a.m. the following morning. This situation only became known when one of the boys collapsed. The directors claimed exceptional circumstances because so many of their employees were now serving in the armed forces and there was a great shortage of labour. They were fined £10 with 10 shillings costs. Such extreme actions show the desperate measures some businesses took to try to ensure continued production.

There was a shortage of tradesmen and, in particular, plumbers. Before the war, there had been 685 men in this trade in Edinburgh, Leith and Portobello. By 1916, it was reported that 'only 127 of military age were left' and 'not a single apprentice plumber of eligible age left'. Maintaining public health was becoming an issue and in May 1916, J. Shepherd, a local plumber, appealed after the exemption for one of his plumbers was refused. He stated,

> It is impossible to replace Operative Plumbers just now and in the future there will be no men left to replace them as such a wastage has taken place in the apprentice ranks owing to the War. The Applicant Employer does an extensive jobbing business in Portobello and surrounding district. He has no men for Contract Work and his whole work is taken up with urgent jobbing work such as choked drains, burst pipes, etc. where extensive damage would be done and it is absolutely essential to life and health that repairs should take place. It is submitted quite apart from the dire results to the Applicant Employer that on the grounds of public health and sanitation that it is absolutely necessary that the Applicant Employer's business should be continued. The ranks of Operative and Master Plumbers have been so depleted that there is nobody left to undertake urgent work. It is the opinion of the Medical Officer of Health for the City that it will be highly dangerous to life and property in the City to further deplete the ranks of Operative Plumbers. The men left are mostly over military age and are incompetent to execute a number of important and often hazardous plumbing repairs.

The Appeal Tribunal directed 'the Local Tribunal to grant a Certificate of Exemption to the man on condition of his remaining in his present employment'. In this instance, the needs of the community were recognised.

Coal Merchant and Contractor, Alexander Roberts, applied for an exemption for his only remaining carter, who had been employed by him for eight years. He gave the following reasons:

(a) If — is taken away from my employment I will be unable to sell coal in bags to my clients in Duddingston, Craigmillar, Portobello and district. I have only one competitor in Duddingston and two in Craigmillar and they cannot supply any more customers.

(b) I have done my best to get a suitable man in his place and have failed to do so. I used to employ four men carting coal before the war and now have only — left. If — be taken away I will have to stop selling bags of coal and only supply such customers buying a ton or more and thus I will lose £100 per annum.

The tribunal decided that 'there are not sufficient grounds to support this application'. A lengthy detailed appeal application was submitted by Roberts' lawyer. It exemplifies the long hours men were working to provide the goods and services still required by those at the home front:

Business
Applicant carries on the business of a Coal Merchant & General Contractor and prior to the War supplied the wants of customers in Liberton, Duddingston, Craigmillar, Gilmerton, Portobello and Joppa districts, by delivering and selling coal to them in cwt. [hundredweight] bags. He also had a considerable business in delivering coal in tons to Edinburgh customers.

Staff
Prior to the War, applicant employed 4 men, three of whom have since joined the army. In November 1915 he engaged Robert and James — as Carters to replace two of his men who had joined. In March 1916 the — left applicant's employment and joined the Niddrie & Benhar Coal Co. as carters, being induced to do so no doubt by the fact that their brother who was employed by the said Niddrie Co. had been granted exemption. All three brothers have now been exempted from service.

 On the —s leaving, applicant has made many efforts to secure assistance but has failed to obtain any. He therefore was compelled to re-organise his business. He gave up his Edinburgh customers entirely, knowing that their wants could be more easily supplied than his other customers. With the assistance of — and applicant actively working himself, and both of them working from 6 a.m. to 10 p.m. six days a week he has been able to supply the average weekly demands of his customers amounting at present to 36 tons. The work he does is of national importance, and it at the same time provides him with a bare subsistence. In the carrying through of such work at least another able-bodied man is needed. From his past experience applicant knows that at present it will be difficult to secure such a man. Immediately, however, the decision of the Local Tribunal was communicated to him Applicant advertised for a man and will continue to do so until he finds one, but in the meantime craves the Court to extend the period of temporary exemption by the local Tribunal.

 It is true that Applicant has another man in his employment. This man was a miner, but is no longer fit for such work and only helps applicant with light work and such that requires no lifting.

 —'s three brothers are now serving, two of whom support their wives and family and the other along with — support their mother.

 If — joins the Army and no one obtained to carry on with his work with applicant, applicant's business will be closed down.

This plea for exemption failed and the appeal was dismissed, with the following reasons given:

 1. That the Applicant carries on business as a Coal Merchant, supplying coals to private houses, and it is not of national importance that his business be maintained.
 2. That looking to —'s age (28) and the fact that he has been passed fit for Foreign Service, it is more expedient in the national interests that he should be employed in military service than continue to be engaged in his present occupation.

Roberts' business was put up for sale.

One local butcher applied for the exemption of his son who helped with the business. When this was refused he appealed stating:

> Applicant has a large butcher's business in Portobello. He applies for the exemption of his son, —, who acts as his assistant kills all the animals and cuts the same up. He also drives the delivery van with goods. Applicant has three sons serving with the colours. At the outbreak of war all his sons were being brought up in his business and — is the only one now left. Applicant desires to retain the service of this son, as he considers him absolutely indispensable for the running of his business. If he is taken very serious hardship will ensue.

The butcher's lawyer later withdrew his appeal, stating, 'We have been instructed to appear on behalf of the appellant but as we really have no substantial grounds to urge for the appeal being upheld we have arranged with our client that the appeal should be held as withdrawn.' It must be presumed that his son did serve. The business did survive and served the community for many years.

In contrast, one teller with the Royal Bank of Scotland was eventually exempt from service. Like the butcher's son he was described as 'indispensable' by his employer. This application was initially refused by the Local Tribunal for the following reasons:

> The man applied for, aged 32, single, is in class A. The Applicants pre war (*sic*) staff was 901. The staff as at 31st August 1917 consisted of 512 men over and under military age, 230 men of military age and 141 women, making a total of 883. After consideration the Local Tribunal were of the opinion that the applicants could release more of their younger men for military service by introducing more women into their employment, and that, it was not in the national interests that the man applied for should remain in his present occupation.

The Appeal Tribunal, however, granted a Certificate of Exemption to the man 'on condition of his remaining in his present occupation'. It is difficult to understand how a bank teller was deemed indispensable, and given an exemption if he remained in post, but a coal carter or butcher's son was not.

Similarly, the head brewer and manager at G. & J. MacLachlan, Castle Brewery, Craigmillar, was exempt from service. Between 1916 and 1918, this man was granted temporary exemptions until, against the appeal by the Military Representative, he was granted an exemption until 12 March 1919, as long as he remained in his present occupation and 'on the Ground of National Interests'. The appeal lodged by his employers in August 1916 gave its reasons in support of appeal as:

> — attested and was medically rejected, and is now called up for re-examination. He is in full charge of our Maltings at Craigmillar, (where we are manufacturing Malt to be used by Distillers engaged on Munition work), also of our Brewery at Craigmillar where we manufacture large quantities of Beer for the troops at home and abroad,

also large quantities of Yeast, which we supply to Distilleries employed on Munition work. He is a man of expert knowledge in Brewing and in the present circumstances his place cannot be filled. He is quite indispensable.

The Military Representative objected: 'I object to the application. In view of the fact that this man has been classified B1 by a Medical Board it is in the National interest that he should be available for Military Service.' However, this was overruled.

MacLachlan's supported their final application for exemption with this statement:

The circumstances of Mr —'s services as Head Brewer and Administrative Manager of our Brewery have not altered since the date of the last Appeal made by the National Service Representative, when he was granted three months exemption, further than that in addition to our ordinary output at the Brewery we have been authorised under Special Licence from the Food Controller, during the current quarter, to brew the equivalent of 2,500 bulk barrels of Beer for Munitions Areas. It is also to be noted that the Brewing Industry is now one of the certified trades under the latest List of reserved occupations, and in that connection we respectfully claim that Mr — should be unconditionally exempted.

This man's final exemption meant that he never undertook military service in the war.

Under the terms of the Defence of the Realm Act, Munition Ale was a lower strength as less grain and sugar were used to make it. The Government believed that if less alcohol was consumed, production would improve. In 1914, duty on a bottle of whisky was 4 shillings. By 1918 it was 20 shillings. Opening hours for pubs were cut and, in October 1915, the No Treating Order banned people from buying alcoholic drinks for others. In June 1916, a publican, of No. 2 Bath Street, was fined £15 for 'having sold a half pint of beer to a soldier, the price being paid by another man'.

Drunkenness was seen as a problem and was clamped down on. In May 1916, a Portobello publican was fined £3 when he pled guilty to the charge that 'on 1st April in his public-house at 227 High Street, Portobello, he supplied a pint of beer each to two privates of the Scottish Rifles while they were in a state of intoxication'. He stated that 'he was unfortunately a victim of an irresponsible servant'. His usual assistant had been called up and he had an old soldier as temporary help. 'Evidently out of comradeship towards these soldiers this man had supplied them with the liquor.'

Bailie Archbold, who was hearing the case, said that there had been many similar cases throughout the town and warnings seemed to be ignored. However, 'in view of the mitigating circumstances of the case, he restricted the fine to the sum stated'.

It is difficult to understand why this particular Portobello man had his exemption refused. He drove a van for James M. Henderson, Scone & Oatcake Bakery, Jock's Lodge, and had previously worked with the Niddrie and Benhar Coal Company, where he badly injured his hand in an accident. The Local Tribunal's reasons for refusal were as follows:

The man applied for (age 25, single, Class CII) is a baker's vanman. He resides with his widowed Mother and is her main support. One brother has been killed on service.

Another is in the trenches and a third brother is an engineer. After consideration the Local Tribunal were of the opinion that (1) it was not in the National Interests that the man applied for should remain in his present occupation and (2) that there would be no serious hardship in the event of the man joining the Army.

His employer appealed:

1 — is the only man in Applicant's employment and the only person capable of driving the Auto-carrier, and there is no one else to take his place.

2 — is 'C' 2 and is deprived of the left hand of four and a half fingers and half his hand. The driving of the Auto-carrier and the delivering of Applicant's goods is the only light work for which he is competent. He is often temporary laid aside from his work through the effects of cold and damp to the injured hand. Owing to the construction of the Auto-carrier which is steered by a bar and with foot brake — is able to drive same with one hand.

3 Applicant's is a plain bakery baking scones with Standard flour and oatcakes. His business is Wholesale and depends entirely on delivery. The delivery extends from Musselburgh to the outskirts of Edinburgh. He supplies Dairies, Bakers, Restaurants and Canteens.

4 The Applicant's goods comply more with the Food Controller's desires than even bread, as he uses more chemicals instead of yeast and dispenses with oils and fats, and the Applicant's business is of direct national importance, and depends upon delivery which is eminently suitable to a disabled man like —. He would be quite unfit for any work in the Army.

This appeal failed and, according to family members, it was not until the final stages of his medical examination that his damaged hand was noticed and it was admitted that he was unfit for military service. The baker's produce sounds unappetising, but highlights the shortages in the later stages of the war.

Public transport also suffered from staff shortages. It was claimed that 514 of the 1,100 men who maintained the tramway system had enlisted and that those left were unable to cope with the workload, contributing to the intermittent service to Portobello experienced by travellers. Cable-car drivers were exempt from military service if they stayed in their present occupation. However, one driver claimed exemption as a conscientious objector.

Many people accused conscientious objectors of being cowards, but some were prepared to serve in non-combatant roles. Those determined not to participate in any kind of military service, known as Absolutists, could be sent to prison where they experienced harsh treatment and conditions. There were five tribunal cases for conscientious objectors recorded for the Portobello area, including that of the foreman market gardener discussed earlier.

The cable-car driver's application for exemption on the grounds of conscientious objection was refused, as was his appeal when it was stated that 'after consideration the Local Tribunal were not satisfied that he had a conscientious objection to combatant

service'. The Application on the Ground of Conscientious Objection listed ten questions, with various parts, to which the appellant had to give written answers. This man wrote three pages of answers using scripture to explain his objections. Among others he stated:

> My Objections to taking Part in Non-Combatant Service is that that Branch of the Service is Simply a Part of the Military Machine so in the Sight of God there can be no difference between Combatant & Non-Combatant Service. Saul of Tarsus, the Persecutor, Was a Non Combatant When he held the Clothes of those Who Stoned Stephen but he was Verily as Guilty.

He further stated:

> I wish to say that I have no Strictures to pass on this War or any Wars – nor on this nation for engaging in War. I fully acknowledge that the nation has authority accorded to it by God to repress evil and inflict punishment on the evildoers, but refuse absolutely to acknowledge the right of the State to Command me to obey their laws when the Said laws clearly conflict With the Word of the Living God to His Church today.

He eventually claimed and was granted a temporary exemption as a cable car driver 'continuing in his present occupation' on 18 December 1917.

One shop assistant, employed by the Co-operative Society at No. 44 High Street, Portobello, stated in his appeal of 28 February 1916:

> I make a claim for absolute exemption as I consider that if I accept non-combatant service I directly assist in war. Firmly believing as I do that all human life is sacred, I cannot and will not be false to my deepest convictions by engaging in military service. I hold that nothing can justify war and in support of my belief I am prepared to suffer any penalty rather than accept a decision of this tribunal which does not harmonise with my belief.

It appeared to go against him that he belonged to no religious denomination and his manager stated that 'this man evidently wishes to evade service'. The Military Representative supported this. He was granted exemption from combatant service only. He did not accept the decision of the Appeal Tribunal willingly. A newspaper reported on 23 May 1916 that four men failed to turn up for military service when called up. One of them was the above shop assistant. They were fined 40 shillings or seven days' imprisonment and ordered to be handed over to the military authorities. They were then escorted to the Recruiting Office in Cockburn Street. Whether he did accept non-combatant service or refuse to participate in the war in any way is unknown.

The two remaining conscientious objectors described themselves as Ministers of Religion. Both were offered exemptions from combatant service, which they refused to accept. They were both preachers with a religious body called the Testimony of Jesus,

which worked on independent faith mission lines and had originated in the north of Ireland about nineteen years earlier. The preachers had no contracts or salaries but were supported by members of the denomination. They provided certificates and many letters of support from Ireland, but these were discounted and their appeals failed. Whether they served in non-combatant duties or were imprisoned is not known.

It is sometimes possible to follow the fortunes of a conscripted man. This local photographer appealed to the Central Tribunal stating that it was:

> impossible to go on military service without financial and business ruination and serious hardship to my parents resulting. I have a business at 23 Bath Street Portobello which I would have to close if called away, which would mean heavy financial loss. I have also to assist running my father's businesses as he is incapacitated, his eyesight having entirely failed him. If called away it would mean that my father, mother who is invalid and my sister would very materially suffer and who are partially dependant on me.

The tribunal decided, 'That there are not sufficient grounds for allowing this claim.' He was sent to the front and died in France on 4 September 1918, while serving as a private with 13th Battalion, Royal Fusiliers (London Regiment), having previously served with the Royal Scots (Lothian Regiment). He is buried in Hermies Hill British Cemetery, France.

There is no evidence to show how many women took over men's jobs in Portobello. As we've already seen, some businesses lost their whole workforce and closed, with some one-man businesses closing when the owners were called up. In 1916, the business of Thomas Ryder, baker, No. 77 Portobello High Street, was put up for sale as he could not get staff after advertising for many months. A dairy in Bath Street was put up for sale in 1917, as the proprietor had been called up. Portobello Public Wash House was for sale in 1918, as the owner had been called up for military service.

The inconsistent and apparently illogical decisions of tribunals must raise questions about the impartiality of their members. Why should bank tellers be deemed indispensable and food producers not? The national interest was interpreted in a variety of ways, but mostly in favour of sending men for military service. Members of tribunals wielded great power. The decisions that they made could mean the difference between life and death for the person before them. Portobello may have lost fathers, husbands, sons and brothers, who could have served their country equally well by being allowed to continue to practise their much-needed skills at home.

CHAPTER 5

DEAR NORAH ...

When war was declared, Norah Torrance lived with her family at Mount Lodge in Windsor Place, Portobello. Her mother had died quite suddenly of a brain tumour on 14 July, leaving William Torrance with his daughters, Mona aged twenty-four, Norah, sixteen, and Roma, just thirteen. William was very hospitable and decided to invite some of the soldiers billeted in the area, and sometimes convalescent soldiers, to spend time with him and his three daughters at Mount Lodge. They had a huge garden with fields and ponies and a tennis court marked out on the lawn. Norah, who was a very pretty girl, wrote to several soldiers from 1915 onwards. Some she already knew from Portobello and others had convalesced with them.

The collection of letters written to Norah has been treasured by her family, and Dorothy Kelly, Norah's daughter, has allowed us to use them, along with photographs and additional family information to tell their stories. The soldiers looked forward eagerly to Norah's newsy letters, the contents of which can only be guessed at by reading the replies she received.

Tom Purves was a member of a large, well-known Portobello family. In the 1911 Census, Tom was fifteen years old and employed as a clerk in a colliery office. He lived at No.15, West Brighton Crescent. In the Record of Honour of Old Scouts of the 3rd East Edinburgh (Portobello) Troop of Boy Scouts (attached to St James's church), which was compiled in December 1914, Tom's address is No. 21 Argyle Crescent. The record is a list of those who were then serving in the Army, Navy or Territorial Forces. Tom was a Patrol Leader. The family later moved to Ann Street, but continued to attend St James's church. It appears, therefore, that Norah would have known Tommy before they moved.

When the war began, Tom Purves joined the Queen's Own Cameron Highlanders as a drummer. He was first stationed in Richmond, then Inverness and Stirling and daily nagged his officers for release to go to the front. Norah and Tom exchanged letters regularly. He is believed to be her first boyfriend and was certainly her first correspondent, but there are no letters from the front. Tom was killed at the Somme on 23 April 1917.

Tom never dated his letters, but they must have begun in 1915. Here are a few extracts:

A young Norah Torrance.

No 15901
Drummer T. Purves
The Band 8th Camerons
Richmond Camp
Yorkshire

My Darling Nora,

Just received your nice letter by this morning's mail and make all haste to reply to it, as I know you like to hear from me as often as possible, but please don't be angry if it is rather jumbled, as there is a terrific noise going on just now with bagpipes, dancing etc.

So you liked the little piece of poetry did you, Nora? I do occasionally try my hand at composing, but don't call me a poet. Your piece, Nora dear, was exceptionally nice and very true. When I read it, I couldn't help thinking you had spent some time in America, as you have quite acquired the American twang. Glad to see, Nora, you are making such good use of your spare time. Personally I prefer to read books of adventure and excitement. I never could stand Shakespeare, but had to do it at school much to my disgust.

You must have been swotting quite a lot lately to win a scholarship and several other prizes. You have my warmest congratulations and best wishes for the future. Surely this is reward in full for the hard work you have done during the session.

So Jim had been home on leave and the bounder never told me. Won't I give him a telling off. I do hope he enjoyed himself. I don't want to say anything against Jim, but I am afraid

he leads a rather fast life down in Selkirk with girls etc. Still you can't blame him, for it diverts his mind from the monotony of his everyday life. If I hadn't a nice little girl at home, Nora dear, I think I would do the same. I have had rather a lazy day today. Practising in the forenoon and preparing for a route march tomorrow, cleaning my drum etc.

Now, Nora dear, I am afraid this is rather a short letter, but as there is practically no news just now, you will forgive me … won't you dear? By the way how is Mona? I hope she has quite recovered from the effects of having her teeth out. Now, please don't forget to write, as I always enjoy hearing from you.

With fondest Love,
Yours Ever,
Tom

Queens Own Cameron Highlanders
8th Battalion
Richmond Camp

My dearest Nora,

I received your very welcome letter this morning after coming in from a fairly long route march and it cheered me up greatly. Forgive me, Nora dear, but I had really begun to think you had forgotten all about me, but glad to find that such is not the case. Of course I know that you must be awfully busy with your lessons and consequently haven't much time to do correspondence, but still I looked forward to having a little note from you.

I was very sorry to hear of the death of your Grandma, Nora, but God's ways are not ours and perhaps it was for the best. There will be many sad hearts this Christmas, but we must all be as cheerful as the circumstances permit and hope and pray that the time will soon come when peace shall once more reign in the country.

Now, Nora, for some news. Guess? Well, I am coming home on Friday this week for a day or two, so will try and pay you a visit on Monday, so if convenient you might try and keep that night free. Will you dear?

Now, Nora dear, I must ask you to forgive me for writing such a short letter, but I have a lot to do and I have no idea where to start. I still have about a dozen letters to answer and I also have to prepare for guard tonight, so will close.

With fondest Love
Hoping to see you on Monday 1st.
Yours,
Tom

Richmond Camp

My dearest Nora,

I received your nice letter the other day for which I thank you very much. Don't apologise, Nora dear, for not writing before, I knew that something important kept you so busy, so is it all right now? But you have no idea how eagerly I look for your letters.

You certainly must be awfully put about with Mona's misfortune and your lessons at school and I hope you will be as successful this term as you were at the last.

Your father seems to like entertaining soldiers, Nora, for, if I remember rightly, you told me about some who had been at Mount Lodge before I was home on leave. I hope to have the pleasure of hearing the new assistant minister the next time I am home and the pleasure of your company to church, Nora, on that occasion.

Poor Corrie Brown seems to have had a bad time and you say he deserves to enjoy himself and if everyone was like you, Nora, I am sure he would thoroughly appreciate his furlough at home. A draft of 150 men left here to be transferred to the Black Watch who leave for Mesopotamia on Monday. As that is an extremely warm part of the globe, they were all issued with sun helmets and light suits (khaki). We will probably get the job to play them to the station, for although they are now 'Royal Highlanders' we can't forget they were once Camerons.

Nothing extraordinary ever happens in this dismal place, always the same stale routine – Route Marches, Church Parades and Practice. Quite a number of our fellows are back from France, who went out quite recently. They all advise me to stay in the Band, but several times I have put in an application to get out, as I wanted, to the front, but they have always refused. Don't tell anyone in our family this, Nora, as it would upset Mother, if she knew. Wouldn't it be rotten if the war finished and you had to admit you had never seen active service.

Now, Nora dearest, I must close hoping you will excuse the scrawl and the shortness of this letter.

With Fondest Love and Kisses,

Yours forever,

Tom

P.S. Kindest regards to all.

No 15901 the Band
8th Battalion Cameron Highlanders
Hayford Mills
Cambusbarron
Stirling

My darling Nora,

I really don't know what you will think of me for not writing before, but as I have no plausible excuse to offer, I must ask your forgiveness.

I am afraid we didn't have very long together when I was home, but nevertheless I enjoyed myself immensely on Sunday evening. I liked the other fellows very much and it reflects a credit on you for keeping such excellent company. By the way, Nora, who was the nice young lady present on that occasion? I was introduced to her, but I really forget her name. She seemed to be very quiet and reserved, ... like yourself ... what, what?

So you have decided to cast aside 'flapperdom' and to take a serious aspect of life, have you dear? Well it's a big step to take, Nora, but I have no doubt you will realise it only too soon, but never get downhearted, there is a good time coming as you say.

Now please accept a compliment. You look absolutely charming with your hair up. Please reprimand me if I am getting too familiar.

However, dear, I haven't quite given up hope of going to France, as I heard it rumoured that Lloyd George issued an order that all fit drummers were to be sent to France (loud applause!)

So dear, do not mention to Poppy that I was volunteering to go away, as she would be sure to tell Mother and that wouldn't do. Mother, you know, is under the delusion that I will never go, so I think it is best to leave her in ignorance of the fact. Just now at any rate, as her health and system is so far run down.

By the way, Nora dear, (I hope you won't be angry) I do love you. Something has come to me since last we met, I don't think I could walk out with another girl.

Now dearest, I dare not trust myself to say more at present, but will live in constant thoughts of you until I receive my answer.

Please dear, do not disappoint me.

With Warmest and Fondest Love to your own dear self I remain,

Ever your admirer,

Tom

That was the last letter Norah received from Tom. His notice of death appeared in *The Scotsman* on 25 May, 1917, as follows:

Purves – Killed in action 23rd April, Private Tom Purves, Cameron Hrs, beloved second surviving son of Mr & Mrs Purves, 9 Ann Street, late Argyle Crescent, Joppa.

We do not know if Norah replied to Tom's last letter, or if she felt the same way as he did. What these letters do show is how much even what would seem the most mundane information meant to those serving at the front.

Norah met Harold Smith when he did his training with the 31st (Reserve) Battalion Royal Fusiliers at the Marine Gardens. When his training was completed, he transferred to the 26th (Service) Battalion (Bankers). Harold came from Hull, where he worked in the National Provincial Bank. He joined the Fusiliers at age nineteen in 1916 and desperately wanted to get into the Bankers Battalion. These are letters from Harold to Norah, written during 1917. He was declared 'missing in action' in October 1917.

Marine Gardens Portobello
31st May 1917

My Dear Little Pal,

I got your note this morning and am fearfully sorry you can't manage tonight. However, as I said, I am at your disposal, so shall we say tomorrow (Thursday) at 6pm. At the lane gate. We can decide then what to do with ourselves. As for Saturday, I am afraid it will be Brigade Day, though we don't know officially yet. It would be just our luck.

"For King and Country."

KILLED IN ACTION in France, on 23rd April 1917,
Private THOMAS WIGHTMAN PURVES,
7th Cameron Highlanders.

*Mr and Mrs Purves and Family
return thanks for sympathy in
their great sorrow.*

*9 Ann Street,
Edinburgh.* *May 1917.*

Above left: Notice of death of Thomas Purves.

Above right: Harold Smith.

*Have been trench digging all day and after cleaning up am going out for a quiet
game of billiards. Bet I shan't be able to play respectably – thinking with a nasty pain
of what might have been. I am thinking quite a lot of things about Marjorie.*

But there is a fellow waiting for me, so I must ring off here.

Love and-er-other nice things –

Harold

Portobello
11th June 1917

My own dear little – er – what you said,

*With reference to the arrangement made at our interview yesterday, I have to inform
you ... no, that isn't right – it's a throwback to the dear dead days and doesn't agree
with my opening. What I mean to say is, that there is a route march on the programme
for tomorrow afternoon's performance, which will probably be lengthy and throw us
late. Wherefore I think 'twould be wise should we alter our appointment to 7pm au
lieu de 6.30. by the way, I find the others had fixed tomorrow at the same time and
are making the same adjustments.*

Hoping this will not inconvenience you my love,
I am yours as closely as possible,
Harold

National Provincial Bank of England Ltd.
Hull 28th June 1917

My Dear Norah,

This leave of mine came off and here I am, working quite hard, for a change. Anyhow, I haven't forgotten quite all I knew about banking, I find, though it seems strange to be at it again. The office is like a harem now – there are about ten 'temporary lady clerks', it makes poor me feel horribly shy. One in the Portobello pictures is better than ten in the office any old time!

Can you find time to write to me a wee note to cheer my weary way? My house address is 65 Alexandra Road, Hull. You can tell me all about the nice new boys this week.

Expect to be back in Edinburgh on Sunday night, so please don't book up all week.

Miserable till I hear from you, I am,
Yours truly,
Harold
(in haste)

65 Alexandra Road Hull
5th August 1917

My dear Norah,

I was pleased to learn from your letter of Wednesday that you are having a good time and that you are cheering up. But Ossian in the old Erse sounds a wee bit advanced. I have never tackled it. But then, I am afraid, I haven't quite got the literary temperament I once imagined I had.

You will see from the above that I also am in the thick of a little holiday. Arrived here about 5am today and am due back in barracks by 8.30 next Friday morning. I don't think I shall find much time for reading while I am here. My brother has just got his commission RUR and leaves on the thirteenth, so I am fortunate in getting my leave just now.

Sammy and all our crowd are also among the 80 men of D Coy now on final leave. When we return we are safe in Edinburgh for at least a week – on a bombing course – but after that anything may happen. Are you likely to be home again within that time? I hope so. You might let me know will you?

Please excuse my hurried scrawl, I have more things to do and people to see than can possibly be squeezed into six days. Just at present the brother aforementioned strongly desires me to go out with him – and it must be.

So for the present – Vale!

Love etc from
Yours,
Harold

Sunday 1st September 1917

My dear Norah,

We have now left that base I told you so vaguely of and have definitely become members of a battalion – the 26th RF [Royal Fusiliers], the original Bankers. Rather strange that I should get here after all to the crowd I originally tried to join; the battalion whose remnants we loved so much in Edinburgh. However, we are lucky; they are a splendid lot of fellows to get on with. Some of the draft were not so fortunate – Vivian Lang with others was sent off to another battalion, the first, I believe. Sammy's physical failings have at last to some extent been recognised and he has had to leave us temporarily at any rate to take a police job. I don't quite know where he is, but I expect he is all right. White is still with us, sitting beside me. I fancy that he is also writing to sweet Scotland.

We have not yet had any letters sent on from the base; I am hoping to have one from you when they do come. I am writing now to give you my definite address, which is

2290 Pte H. S
D Coy, 1st Platoon
26 Bu R F
BEF France

Up here we are not far from the line and I am getting used to the thunder of guns. We shall be right in the line soon, but we don't know just when. And how are things up there now? They tell me the 31st R. F. is no longer so, but that they now bear simply a '107'. That will not be at all nice, and if it is so, I am glad we came out as Fusiliers.

Sunday afternoon, and no plans for the day's amusement! Oh to be back in Porto would be good. We haven't really had time to get fed up properly yet, but I can see the difference between the two kinds of soldiering.

Am hoping to have that photo soon, something to look at, think about, even kiss for lack of your dear self.

Harold

His last letter:

Somewhere in France
Saturday 30th September 1917

My Dearest Girlie,

Thanks ever so much for your letter of Sunday which arrived yesterday. This is absolutely the first free moment I've had to commence a reply. How long I shall have now is doubtful. I'm awfully glad the photos pleased you. The Battalion has just come

back after a few days in action and it hasn't come back as it went up, by a long way ... To bivouac in a field of mud is a joy I would fain be denied. I had many long miserable months at home before that bank released me. Now I've already got what is the general view out here, that to be back would be a great joy. Oh horrida bella!

Here we are grouped well behind the line carrying on something like home training. Still it's better than being in the line. I don't suppose we should be in those pictures you have seen, those on show now would not be sufficiently up to date. You may see us later.

Lord how your letter set me thinking – sometimes in contrasts. Mist on the grass – dew on the flowers in the gardens where we have had so many ripping times. It sounds fine – against which on the ground here dew or something rather more so! Soaked through the bivouac so thick I would almost back a French dew against a Scotch mist.

We had a singsong last night round a huge camp fire. Memories again! I can never join in 'The Long Long Trail' without thinking of many things and the cheery long-suffering Roma generally comes into it.

All that was yesterday. It is now Sunday morning. I have just come off Church Parade and have at last a little time to call my own. And that little is yours.

I am writing in brilliant sunshine, the country around looks lovely – but the War is very present. The only town I can see is a ruin, the guns rumble on though more distantly than before, aeroplanes pass constantly overhead and so on and on. And that's quite enough guff for a good Sunday morning.

Thanks for sending these photos to my Mother. I am hoping to have one of yourself quite soon.

I shall try to write again quite soon and I know you will. This last week I have had practically no opportunity, we are kept at it pretty well.

Love from

Harold

Nothing more came from the front. Then in January, 1918 a letter arrived at Mount Lodge.

Dear Miss Torrance,

You will be surprised at receiving a letter from me. Perhaps you didn't know that Harold had a sister. I've felt for a long time that I should like to write to you, that perhaps Harold himself would be pleased for me to do so. I think I feel just a little bit nearer to him when I write. Of course we don't know whether you two were just friends or whether you were perhaps more than friends. Harold just said, 'Norah Torrance is the best friend I have made out there' and that is all we know, but we are all grateful to you for making time pass so much more pleasantly for him. I am afraid we have none of us very much hope left. You see – he was so thoughtful that, if he had been unable to write himself, he would never have rested until he had found someone else to write.

Besides, I think Father has corresponded with almost everyone who would be likely to know anything. We should have been sure to receive news had there been any news

to get. Still, above common sense, a tiny ray of hope pushes itself sometimes and wouldn't it be glorious if he did come back after all.

I don't suppose you ever get as far as Hull, but if you do, I shall be very pleased indeed to see you and make your acquaintance.

Yours very sincerely,

Frances Little

Many years later in the 1930s Norah and Bertie, her husband, were holidaying without their children, probably in Scarborough. They drove to No. 11 Ash Grove, Hull. There was noone at home, so Norah pushed a note through the letter box. A few weeks later, this letter arrived at No. 45 Wakefield Avenue, Edinburgh:

Dear Mrs Cavaye,

I was certainly very surprised, but also very pleased to hear from you. I still have your photograph treasured along with Harold's last letters. The time you mention on the moors at Scarborough was the last time I saw him. Harold and Edward came back from the moors and stayed the night, then I said Goodbye to them in the morning – not dreaming that it would be the last time. Father wrote to officers and other people who were in the same battalion. No one seemed to know anything. It had evidently been a terrible time and the loss cruelly heavy. It seems such a long time ago now doesn't it? I am so glad you still have such sweet memories of Harold – he was worth it bless him. Thank you so much for your letter.

Yours sincerely.

Frances Little

Maurice (Mossie) Duncan was an officer in a Scottish cavalry regiment and got engaged to Norah early in 1918, before he spent several months in the trenches. It seemed to those that knew him that, when he came home on leave that summer, he was not the same idealistic boy he had been before he went away. All the Torrance girls thought he lacked a sense of humour. Later, Norah decided to break off the engagement to Mossie and gave him back his ring.

Kilkerran

Maybole

Ayrshire

Tues 22nd

Girl of my Dreams,

Well Kiddie I managed to get back here again alright and I found everything ready for me. The trap was at the station and Dennis was waiting me. I felt rather tired after my strenuous week and so, after satisfying my hunger, I went to bed. When I woke up this morning I felt very discontented. It is hard luck just getting home for a few days when one wants to stay for good. But I suppose I am very lucky in one sense and should really not grumble.

Mossie Duncan.

You know, Kiddie, you can't realise how glad I was to see you. I meant to say a lot, but I simply couldn't. but you know, Dearest, how it feels when you want to say lots of things and you can't.

Please don't think I was cold and unresponsive. It would grieve me to think you thought that. But I was just overcome with joy at seeing you after all these terrible and weary months.

I think you were looking awfully well and just the same Dear Wee Girl as before.

You would probably think me a bit queer. I know my people did, but I am afraid I have not quite got over the shocked terrible times of the past five months.

Well Kiddie, remember me to all.

Hoping to see you soon.

Yours Ever,

Mossie

Dryfeholm
Lockerbie N.B.
Dumfriesshire
Monday 8th.

Sweetheart,

I am so glad to get your letter, it has relieved me quite a lot. I know now everything is alright. You have explained yourself very well. I understand all now.

Kiddie, as far as I am concerned the matter is finished with. Don't let us talk of it again, Norah dear. In cases like that, it's what you think best. 'Do unto others as you would like others to do unto you' If you do this, everything will go swimmingly with us.

Darling, you don't know how much I care for you. You will some time I hope. I sent you rather a peculiar letter yesterday. I hope you read it as I meant you to read it. That is, it will help us to understand each other a little better.

Darling it is no good telling me that you were to blame. You were partly, but not wholly responsible.

FINIS

Mossie did well after the war and eventually married someone else. He became a marketing man in Naples for an Italian firm. One morning in the mid-thirties, when Norah was in the middle of her housework, Mossie glided up Wakefield Avenue in his expensive Alpha Romeo coupé and stopped outside No. 45, to the delight of Norah's children. Norah stayed unruffled, despite her untidy appearance, and they had a nice chat reminiscing; then he came back out and drove away, almost to cheers from the gang of dirty kids.

Julien de Wildeman.

Julien de Wildeman was a Belgian soldier who was recuperating in Edinburgh City Hospital and was invited to convalesce at Mount Lodge. Norah had a gift for writing and was good at English and French. She even composed English poems out of some of Victor Hugo's well-known verses, to be published in her school magazine. When Julien left to go back to the Belgian Front, she offered to write to him in French, even though she was already writing to several other soldiers.

Julien seems to have had something to do with telegraph and wireless. He was a '*cycliste*' and spent some time away from the hurly-burly enclosed in a little wooden shed sending and receiving messages. This kept him out of the front line for a time, but he found it very boring. In common with many others, once Julien experienced the front line, he kept quiet about the worst of the horrors. Soldiers seemed to do four to six days in the trenches, then four or so days behind the trenches for a rest, then four days in reserve ready for an emergency, before going back into the trenches again. Julien was intensely patriotic and a Royalist. He had two brothers, Joseph and Albert, who were also at the front.

As most of Belgium, including Ghent, was under German occupation, Julien came to Scotland for his leaves. He once went with the Torrance family on holiday to Lauder. When Norah got engaged to Mossie Duncan in spring 1918, Julien was very disappointed. When she told him she had to write secretly to him during that time, he selflessly told her that they should not write any more, for fear of upsetting her fiancé. In late 1918, when Norah broke off her engagement, pleading she was too young, the correspondence with Julien started again, but it was never quite as emotionally charged as before.

Over the years, Julien wrote some forty letters to Norah from the Belgian Front. These letters were translated by Dorothy and a selection is given here:

Sunday April 8th Easter Day
A Happy Easter to you and the whole family. I just received your letter of the 2nd April, the day I left. Yes, my dear little friend, I won't try to hide it, I was very sad when I was leaving, but now I feel quite comforted by receiving your lovely little letter. In fact I believe I have found a little friend with whom I am going to correspond, so I can forget everything that is going on around me and be able to enjoy a bit of distraction during my hours of relaxation. You cannot imagine the pleasure one gets, especially when one is in the trenches as a poor soldier, just getting a few words of encouragement. For the moment I am in the shelter of the dunes. I am on guard every other night along the coastline. I am glad I made you laugh by saying your French was perfect. I shall have to do all I can to make it better. I shall be delighted to get your news from time to time, for I think of you every day. You have made me so happy.

Sunday 13th May
Here I am arrived at the billet and someone shouts at me, 'Julien, Julien there are two letters for you!' I recognised my little friend's writing immediately.

Without wasting a single minute and even before eating I read your delightful letter which made me very happy. Being worn out with a night's work, just reading that

lovely letter I felt rested. Yes, I have returned to the front for several days. I do 4 or 6 days in the trenches, then 4 days rest and 4 days as reserve and so on. You ask if I am thinking of returning this summer to Scotland. Well, there's nothing I would like better than to see all my friends especially my little friend, Norah. Unfortunately you can't say beforehand, for an accident easily happens, but I hope I have the good luck to cross the North Sea once again. I leave tomorrow night for the trenches for 4 to 6 days and I certainly hope everything goes as well as it can. Inside this letter is a little photo and you will see how I am already sunburnt. At the moment it is terribly hot. Many compliments to your Father, to your sisters and all your dear family. I am looking forward to some news from you when I come back out of the trenches.

Goodbye, Julien

Saturday 2nd June 1917
I came back last night from the trenches and everything had gone quite well. We are getting bombarded from all sides and at night you can only hear gunfire spreading death and murder everywhere. We are at War, after all! Last night we were marching along happily to our rest place, when we heard a signal by trumpet and bugle, 'On your Guard!' It was the alarm for asphyxiating gas. An attack had been launched and there was nothing but canon fire and explosions. There was rifle fire too but the canon roared the loudest. Some hours later all was quiet again. Birds flew up in the air singing and the sun shone more beautifully than ever. It was all set for a beautiful hot day. The Red Cross ambulances drove off in a long line carrying their precious burdens to hospitals where they can receive the necessary care. We have fought a war but tomorrow you will read in the papers, 'All Quiet on the Belgian Front.' Thank you very much for the file of four-leafed clovers that you gave me for good luck. I carry them with me always as a reminder of my dear little friend Norah. I adore your beautiful country and above all being close to your lovable and charming self.

Thursday 13th September 1917
I learn from the paper of the great events happening in Russia. Possibly you think that this serious question will make a bad impression on the Belgian army. Not at all. We read the papers with indifference. We are fighting for right and for justice and we have absolute confidence in the victorious end to it all.

Wednesday 24th October 1917
My dear little friend I am happy to let you know that I am still in one piece in spite of the terrible hardships I have suffered these last few days. Many of our soldiers paid with their blood for this noble victory. In my Battalion 135 missing including many officers. It is to the rest of us, the foot soldiers and the cyclists, that the liberated inhabitants have shown their joy and gratitude, for we were the ones to come back first. We are only 70 miles from Ghent. Do you think I am going to be able to see my dear Mother again without going through the War Zone? I shall tell my Mother about everything you have done for me during my leaves ... I wish our brave soldiers may return as soon as possible, that our national flag will fly over our magnificent

Belfry when the King re-enters Brussels with his little army. Then the Jocks with their bagpipes will march into Edinburgh to the sound of their National Anthem.

 Only then will the happiest day arrive for all of us.

Aerschot, 23rd November 1918

Ten days have already gone since I arrived in Ghent. I found my dear Mother in very good health. You can imagine the joy of a mother at the return of her son after a separation of four and a half years. On the very day I arrived they were about to attend the burial of my Uncle who was also my godfather, so I came just in time to attend the funeral service. After Ghent I had to set out for Alost, Brussels, Leuven and Aerschot, where I arrived today. It is impossible for me to describe to you our triumphal entry into Brussels. There was no way you could move through the crowds. We were covered in flowers and flags and gifts galore. The joy of the people of Belgium knows no bounds. I saw plenty of British prisoners as well. They are enjoying their share of the glory. And that's quite fair. Today I arrived at Aerschot, which is called a Martyred Village. It suffered burning, looting and massacre at the beginning of the War.

 I am looking forward to getting some leave to spend at home in two or three weeks. I am thinking of going from here to Liege to continue with our victory march to the banks of the Rhine. My brothers are also doing very well.

 I beg you to offer my sincerest greetings to all your family. Now, my dear Norah, I see I am obliged to leave you, while sending you lots of friendly thoughts.

 Your great friend, Julien gives you a big kiss.

These letters touch on some of the horrors of trench warfare. It is uplifting, however, to read of the triumphant entry of the victorious soldiers into the various towns. Julien was in the Army occupying the Rhineland. He continued to write into the 1920s. When Norah married Bertie Cavaye in 1923, Julien sent her a beautifully shaped pale green glass vase, which is still in the family.

Norah also wrote to Bertie Cavaye, whom she had known her from school days, he at Heriots, and she at Queen Street. They used to come down the steps from Portobello station together and set out for home along the Christian Path. To the Cavayes the Torrance girls seemed quite posh, for behind the high wall from the Christian Path there were trees and Mount Lodge looked like a big estate. Bertie was in the grain trade and, although not a student, had been in the officers' training corps attached to Edinburgh University from early in the war. He joined up in 1916 and was commissioned in January 1917 in the Queen's Own Cameron Highlanders. He was on board SS *Cameronia* when it was torpedoed in the Mediterranean. He assisted in lowering the boats and rafts and then, because he was a good swimmer, having trained for years in Portobello Baths, Bertie was able to swim to a destroyer, which took the survivors to Malta. After that, the battalion resumed its passage to India and it is from there that his letters to Norah began.

The letters cover the period 1917–19 and include time spent in India, Egypt and Palestine. These letters are very different from those received from France and mention exotic places Norah could only identify by finding them on a map. A different and mysterious world was revealed by following Bertie's travels.

Bert Cavaye.

c/o Messrs. Grindlay & Co Bankers Bombay
School of Instruction Bangalore
3rd August 1917

My Dear Nora,

I was delighted to receive your letter of the 17th June. It was the only one I received as others will have gone to Peshawar and will take another five days to reach me. I am giving Bombay as my permanent address, as I never know when we will be moved. I must really tell you off (this is an army expression) for writing this letter on the 17th June and not posting it till the 23rd, as this caused a delay of a fortnight through missing the mail. This is most important, but I will let you off if you promise to not let it occur again.

I expect the letter you have received was the one I sent from Aden. I have since written you from Bombay and Cherat. My last letter to you was dated the 27th of June.

Glad to hear you had a pleasant weekend at Carlops. I have spent quite a number of holidays at West Linton. Remember me to Effie and any other of our mutual friends. I hope Roma will make a good job of a photograph of you and that you will send it out … also one of the strictly private ones you mention. It is very enjoyable to look at photos of friends, out here especially … !

Am glad to hear that you are having fine weather at home just now. You would not forget it was summer, if you were out here.

You will see from the address that I have been moved. I was only a fortnight at Cherat. It was quite a pleasant place but very quiet. I left on the 2nd July and spent five days in Bombay on the way here. The journey took five days. You will see from the map that I am seeing a bit of India already, being sent to the North and then to the South. It is really unnecessary, at least in my opinion, to send us here as they are teaching us no more than we got at Gailes. However, it is better than active service. And we are not killed with work. Of course it is not possible to work hard except in the coolest part of the day.

I am interested to hear that you have been reading about India and must say your theories are mainly correct. You speak of the crowded 'city places'. The native bazaar or main street in the native quarter in Bombay is an example. Sometimes you can scarcely move. The population of India is enormous.

The type of native varies considerably in different parts. The Mohammedans here have their caste mark tattooed or painted on their faces, which makes them very ugly. The women wear large ornaments through their noses and ears. Higher caste Indian women who are married are very particular about being seen by other men, in fact most of them are never seen in public after marriage.

Intended writing more, but must stop to catch the mail.

Yours Ever,

Bertie

Grindlay etc
At 1st Seaforth Highlanders
Bangalore
19th October 1917

My Dear Nora,

Delighted to receive your letter of 1st September, two days ago. Yes, it is some little time since I heard from you. I do not consider the excuse good enough that you were waiting on a letter from me. Now that you have finished with school you will have more time to write so hope to hear from you oftener.

Don't mention furlough or being home for Christmas. Both these things unfortunately, unless something unexpected happens, are hopelessly out of the question. Even if the War were to end, which won't happen within the next six months, we would be caged up here for a considerable time. Personally I have been seriously thinking of sticking to the army. However, I should not like that to interfere with getting home for a spell.

Glad to hear you had a ripping time at Lauder. You are lucky. Every time you write you appear to have been on holiday somewhere.

You mention some Americans are coming to Porto. I hope you'll behave when they arrive. Of course you'll say you always do?? I hear the R.F.s have left Porto now and some pukkah (Hindustani for proper) soldiers ... Jocks of course I mean, have arrived.

Yes I heard about the Garden Fete and am glad it was such a success. My people were there and I had a letter saying my lady friend was serving tea. I wonder who they

could mean? I don't think I have any news to give you from this place except that I am still here, although men are leaving from other depots two or three times a week. I believe the Seaforths are over strength in Mespot, so they are leaving us alone in the meantime. No doubt our turn will come alright. Thanks very much indeed for the small snapshot. It is quite chic and I am glad to have it. I enclose a photo of a British soldier in India. What do you think of our new uniform? The usual thing to do out here is to change into mufti after parade.

I received a new kilt from home two days ago. It took over two months coming out. I cannot get a scrap of Cameron tartan out here. Now don't forget I watch the post for your letters.

Kind regards to your sisters and love and kisses to yourself. (excuse the strong language)

Ever Yours,
Bertie

Taj Mahal Palace Hotel
Bombay
29th November 1917

My Dear Nora,

Just a very short scroll to tell you my adventures. I left Bangalore with a draft last Saturday. At 1am, while asleep we arrived at Poona, five hours from Bombay, and were told to get out and march to camp. We were to wait there until there was a boat ready for us. However, I got leave and have been here for two days. Am returning to Poona tonight and expect to bring the draft up tomorrow. We will embark right away. No doubt my next letter to you will be from Basra and I will try to make it long and interesting. Have done nothing except spend money on kit these last few days. This is a most expensive place.

Have sent you today a souvenir magazine.

Yours as ever,

Bertie

Att. 1st Seaforth Highlanders.
Egyptian Expeditionary Force.
26th January 1918

My dear Nora,

What do you think of that for an address? No doubt you will be surprised to hear that we have moved to Egypt. When I arrived at Basra I heard that the regiment was coming down the line, which they did and I joined them at that place.

On the 1st of January we embarked on a small boat and went down river and transhipped onto the Mennetonka, an Atlantic liner, on the 8th. Of course you understand only a small boat can go up river. The only stop we had was at Muscat in S. E. Arabia. There we gained a convoy and sailed for Suez. We arrived at Suez on the 20th after a very comfortable voyage.

I am at present in Ismalia, which, if you glance at the map, you will see is half way up the Suez Canal. The camp is about two miles out in the desert. Very nice, but the sand blows all over the place when there is a little wind or when you are marching. The town is not a bad little place. Quite a number of French people there. Plenty of shops where you can buy almost anything at a price. Am jolly glad we moved here from Mesopot. It was a ------- of a place! The climate here is splendid and bracing, just warm enough but not too warm. Of course it will get warm in a month or two.

Do not know what is going to happen to us or how long we will be here.

I expect we will go up the line here before long. I am living in hope of getting leave to Alexandria or Cairo – not home unfortunately.

It is over two months since I had a letter from you, which is very serious. That, however, is probably no fault of yours, but is due to my moving about so much. I am really getting very fed up of travelling. We should get letters here very much quicker.

Yours sincerely,
Bertie

Palestine
13th August 1918

My Dear Nora,

A letter arrived yesterday and, although I had not seen the handwriting for a considerable time, I thought I recognised it. You did not tell me, Nora, why you did not write for four months. I keep a record of all letters and am certain of the time. Four letters which I wrote you received no answer. I was beginning to think something serious had happened. Won't you tell me what was wrong, especially if I was to blame in any way.

So you are spending a holiday at Fala Hill, Heriot, but your letter is not frightfully enthusiastic over it. Of course, it is rather a lonely spot and you had been laid up with influenza. I sincerely trust that you have completely recovered from the latter, which appears to have stricken half the country. I know Fala fairly well, having cycled through it frequently. I'm hanged if I can remember where the road leads to, however. Truly, as you say, I am forgetting what Scotland looks like. At any rate I think it is

beyond Gorebridge and Fushiebridge, 'Catcune Mills' etc. As you say, the old country certainly is the best.

Things are just dragging along here. We had one very small advance and since then have been sitting tight during the hot weather. That is just about the turning point and should be getting cooler soon. Then we get the rain at the end of next month. And perhaps more than that – who knows?

I have had two short leaves since we came up the line. Firstly three weeks in Jerusalem and just lately a week in Alexandria. I saw the sights of the former (and of course the latter) and took a number of photographs, which I have not yet developed.

I spent quite a fine week in Alex, although it was rather warm there.

We went bathing every day. The only thing that spoiled it was the terrible journey up here.

We managed to finish all the oranges in the country about two months ago. I have now started on the figs and grapes.

No further news to impart, but do not forget I am languishing in this outlandish spot and look forward to a cheery letter from you.

With Kindest Regards and heaps of Love, I remain,

Yours as ever,

Bertie

In August 1918, Bertie was wounded in the Allenby advance on Turkish lines north of Jaffa, and was taken to a Cairo hospital by camel ambulance. He found this very uncomfortable. However, his leg was saved and he didn't have to have it amputated. Bertie's injury was reported in *The Scotsman* of 26 September as follows:

Sec. Lieut. R.M. CAVAYE, Cameron Highlanders (wounded), is the eldest son of Mr Andrew Cavaye, 12 East Brighton Crescent, Portobello. He is 20 years of age, and received his commission in January 1917. Before enlisting Lieut. Cavaye was on the staff of Messrs Philp, Maxwell & Watt, Leith.

Postal Address E.E.F.
Beirut
Syria
6th February 1919

My Dear Nora,

Delighted to receive your letter dated 30/12/18 and have at last found time to answer it.

You appear to be having quite a gay time with dances etc. One seems to be rather out of it being stuck out here, but still there is some hope yet. There is some word of an early move home, so look out, Nora, I will pay you a visit one of these days. What is the best time to call? Mind I did not say immediately, but we have reason to think it may be soon. As you say, quite a number of Porto boys have already got home. I hear Fred Shaw is home. I have no doubt you will know him.

*Have just returned from a few days in Baalbek, but of course you won't know
where that is. It was not exactly a lively place.*

*We have been having a lot of rain here lately. Today is exceedingly stuffy and warm.
I have no doubt that it is pretty cold at home just now. I hope it is a bit warmer before
I come home. Of course one always has a fire at home.*

*I am afraid I have not very much news for you this letter. Am at present doing
Assistant Adjutant to the Battalion and am kept busy with demobilisation. There are
a great many papers and forms to fill up.*

Au revoir

Yours Ever,

Bertie

Don't stop writing, however, as I don't know when it will come off.

Cheerio!

I notice John Matthews has been married to Lily Peace. Do you know him?

The gap of four months in Norah's letters was undoubtedly because she was engaged
to Mossie Duncan for that short period. Bertie came home shortly after this last letter.
He and Norah got engaged in 1921 and were married in March 1923.

Les Dickinson was in the 5th Australian Machine Gun Company and had been
serving in France during 1917. He had a number of cousins in the London area.
While he was hospitalised with a shrapnel wound, he met Daisy Linn, a school friend
of Mona Torrance's, who worked as a secretary in London. Les had leave and was
thinking of going to Italy, for obviously Australians, like Belgians, couldn't go home.

Les Dickinson and Norah.

Daisy suggested he went to Scotland, Mount Lodge and the Torrance family, for his leave, so that is how he met Norah. When Les went back to the trenches, the letters started.

France
9th September 1918

My dear 'Wee 'un',
 Well once again another turn at the guerre is finished and I couldn't score that Blighty. I have two of your bosker letters to answer, so here goes. Well I am glad to hear that you are quite OK also that Mona is so much better. So the lectures appeal to you? Yes, that is a very interesting subject and keeps one thinking very much. Say, you and I think very much alike on that topic.
 Do you remember having a little discussion on that subject one morning in the conservatory? I believe the morning your father spotted us there. Am I correct? – I think so. I'd like to see you teaching at a Sunday School – it seems years since I was at a Sunday School, altho' it was only a few years ago.
 Say, I very nearly managed that Blighty; at present I can't talk and I have blisters all over me – the effects of Fritz's mustard gas. I was nearly blind for a few days, but worse luck I am getting better. I have to see the Doc. tomorrow, so the colonel says. If he is a kind-hearted chap, I may get a little rest, but I'm afraid it's not bad enough to get me across the 'pond'. Isn't that hard luck? Suppose I'm lucky tho', I took thirty men in the line and came out with ten – rather a small crew. But we have some very exciting times, believe me.
 At one stage of the stunt, myself with my four guns and about thirty Infantry were well ahead of any of the others and for a thousand yards on each flank was nothing but Fritzes and in front some of his field guns firing point blank at us. Oh it was nice for a few hours. How we managed to dodge all his shells and bullets, gets me. Well, to change the subject, I am sorry you were bothered by that Jones chap. He has me beaten altogether and it wasn't 'Will', because he hasn't scored his leave yet.
 Well I'm waiting very impatiently for that photo of yours. I'll toute suite mine along when they eventuate. In one of your letters you said you were going to see Daisie. Did you see her? I hope so. I have had a couple of bosker letters from her lately – she's great! I've had one from Roma. Say, she's a sport the way she wrote. Has she ever said anything to you re that subject?
 Well, we are out, having that long looked for spell, so there's not much chance of Blighties for some time, unless I can work this gas stunt.
 Well, Norah, I guess I'll ring off. Remember me to all at home. Thanks for that kiss you sent in that last letter – but I'd much prefer a real one, but c'est impossible at present.
 Cheerio, Wee 'un, ecrivez bientot s.v.p.
 Your sincere pal'
 Les

The care of casualties followed a standard procedure. During the course of the war, 637,746 military and Red Cross hospital beds were established on the fighting and home fronts. Casualties were brought straight from the trenches by Royal Army Medical Corps (RAMC) to be given first aid. They were then taken to Regimental Aid Posts or Field Dressing Stations to be treated by doctors from RAMC. Only life-saving treatments were given here. Casualties were then moved up the Lines of Communication (LOC) to Casualty Clearing Stations (CCS) where they were cared for by volunteer and military nurses, medical orderlies and doctors. It was here that any specialist care or treatment was given as soon as possible. Once they were stabilised, casualties were then moved further up the line on hospital trains to Stationary, Base and General Hospitals. The General Hospital was the last stop before casualties were brought back to hospitals in Britain, or 'Blighty' in Army slang.

During the First World War, 'Dear old Blighty' was a common sentimental reference describing the longing for home felt by soldiers in the trenches. A Blighty wound was a wound serious enough to need recuperation away from the trenches, but not serious enough to kill or maim the victim. Sometimes these were self-inflicted when men shot themselves in an attempt to end their service on the front line. A self-inflicted wound (SWI) was a capital offence and, if discovered, a man found guilty of this faced execution by firing-squad. Of those in the British Army found guilty, none were executed, but they all served periods in prison. The term Blighty was also used by First World War poets such as Wilfred Owen and Seigfried Sassoon.

27th September 1918

Norah Dear,

Just a few lines as I'm in somewhat of a hurry and I don't think there will be any chance of writing for a week or so.

They were making us earn our money once again, but I don't suppose we must growl, we've had quite a nice rest the last week or so. You no doubt know whereabouts we are, if you glance in the papers now and again.

Well, 'Wee 'un', I hope you are quite OK.

Mona, how is she getting along? Out in the garden I suppose, if the weather is at all good. Say, it takes quite a while for a letter to come from E'burgh – about seven or eight days. Some time, isn't it?

There, Norah, I have to get along and do some work, so please excuse the briefness of this note. Write soon, please to

Your sincere pal

Les

Say, Norah, I have been wishing I had a photo of you, so please send one along, if you have one to spare. I'll send you one when some arrive. So Roma hasn't said anything to you yet?

She hasn't answered a letter of mine yet either – am waiting its arrival.

*Yes, 'Maid of the Mountains' is a bosker affair isn't it? One of the best I've seen.
Well Norah, I'll imshie now. Write soon and don't forget that photo, because I should
like to have one very much.*

 Les

*France
15th October 1918*

Norah dear,

 *Well, I am having a rest. As the result of that gas stunt of mine they gave me a week
at an Officers' Rest Home at Paris Plage just south of Boulogne. I arrived here today
and it'll do me for any time. We are living in a huge hotel and everything is OK.*

 *Not such a bad stunt after all – this getting gassed. The only trouble is I can't speak
properly yet. But I can speak a little, as things are N.T.B.*

 *Say Norah, don't you worry or think too much about that spiritualistic stunt of
yours. A certain amount of that is alright, but Norah, don't overdo it svp. Well, I'm
afraid I shan't be able to make this Blighty. 'Tho I was very close to it for a few days,
but as we were out of the line resting, I was fairly comfortable in billets, they didn't
send me to hospital.*

 *Well, I will not receive any more of your letters till I get back to the Coy again. And I
hope there will be quite a few waiting for me. So Mona is worried about her husband.
Well, there's not much time for letter writing and those service cards are the only
available means. I hope she is feeling ever so much better now. Say, don't forget that
photo of yours. Je l'attend avec beaucoup d'impatience. Envoyez le moi aussi vite que
possible svp.*

 Remember me to all at ML.

 Je vous envoie un baiser

 Your Aussie Pal

 Les

*Ward 10
3rd London General Hospital
London
22nd October 1918*

Ma chère petite Norah,

 Well what did I tell you about my nice little Blighty. Come true didn't it!

 *Don't worry, I'm not feeling too bad, but the trouble is a fairly annoying cough and
hardly any voice, so that's a mere detail. All the same I'm jolly glad that I didn't collect
any more of his mustard gas. It doesn't appeal to me very much, methinks I'd much
rather have a wound. I just managed to collect enough to get me over here, that's
about all.*

 *Well, now I'm here, I don't feel like hurrying out of England (unless it's to Scotland
of course) the winter is much preferable here than in La Belle France.*

Somewhat of a coincidence this is the same ward as I was in during my recovery from the Blighty last October. I was only a day out – last year I stopped the piece of shell on the 11th October and this time it is the 3rd October. Very close...

Well Norah, how's things up your way? I don't think we'll have to wait that five or seven months, 'cos I'll be getting some leave after this trip. So I've asked that my pass be made out for Edinburgh. This is a very free and easy hospital, so it'll do me. After the Doc comes in the morning, if a chap can walk he can go away till 10pm. Hard to take isn't it? It only takes about twenty minutes to get to the middle of London. I have plenty of relations within Cooee of here – more or less. I'm expecting some of 'em to come along this afternoon.

Well 'Wee 'un' I'll have to knock off now.

Ecrivez bientôt svp.

Je vous envoie un baiser

Your sincere pal

Les

3rd London General
23rd October 1918

My dear Norah

Thank you very much indeed for your photo and letter which came along this morning. The photo is bosker and also the letter – cela va sans dire.

Say I don't know how it happened that you didn't have any letters for three weeks. I didn't write for about a week, that was the longest. Perhaps they'll arrive very soon. I'm awaiting your letters you sent to the Company. Sans doute they'll arrive during the next week or so. Say Wee 'un, you don't want to worry about this gassing stunt of mine – it's nothing serious.

Personally, I think I was very lucky getting here at all. Also you can bet your life I'll be up to E'burgh just as soon as I can, you can be sure of that. You know how I detest London and like Edinburgh. I just missed going to Scotland – Aberdeen. If I'd come across one boat earlier, I'd have struck it, for the whole convoy from that boat went there.

Yesterday I kidded the Doc that I was quite able to go for a stroll, so that after a bit of inducement he consented. So every day now I can go out from 12 till 10 pm. Not too bad is it? Only trouble is a chap has to get along without talking much, but I guess that will be quite OK very soon.

Otherwise I feel quite OK. It got me in the chest, so of course a chap comes in for a good deal of coughing, but that's a mere detail. All that matters is that I am over here and will soon have another chance of seeing you.

Yes thanks, my eyes are OK again. – they were somewhat crook for a week or so, I could hardly see. Well Norah dear, I'll ring off now.

Write soon please.

Love from

Yours as per,

Les

Warminster
3rd December 1918

My Dear little Girl,

 Well, once again to try and write you. Things have been moving somewhat the last few hours.

 I think I have managed to get out of the row for being away without leave and secondly re this Aussie stunt.

 From all accounts we move from here on the 7th and go to some other camp and embark from there on the 14th, but whether all this comes off is another thing.

 In the meantime I am trying to get three or four days to run up and see you again, but I don't know if I'll succeed. If I don't get up there, you can rest assured that it won't be through any fault of mine, 'cos I'm trying my very hardest. I wish they wouldn't be in such an awful hurry, but that's the military style.

 Ten to one we shall still be here for another few months after all their hurried preparations. That's the usual way isn't it?

 I'm so glad you didn't get into a row about coming to see me off. Thank Mona for me, will you. Gee, isn't she a bosker! Say Kiddie, I do want to see you once again very very soon and it's rotten to think that they may not give me leave to see you.

 Say dear, we got to know each other very well during those last few days, didn't we? And Kiddie, thank you, thank you once again for that kiss on that last night. Gee Norah dear, It was bosker of you to give me that. It is one of my more pleasant memories. I wish I could go with you to that dance. If you go I trust that you'll enjoy yourself.

 I'll bet you do miss Charlie. He's a bosker isn't he? Roma must have a peaceful life now she doesn't have Charlie to give her a 'rough house.'

 Well dear, I'll let you know just as soon as I can what they are going to do with me. Je veux voir ma petite Norah. C'est ce que je desire au present.

 Write soon svp to reach here by the 7th and after that to Croydon.

 Kindest regards to all at Mount Lodge and best of love to you from
 Yours
 Les

Warminster
30th December 1918

My Dear little Girl,

 Well arrived back here OK yesterday afternoon and as luck would have it I could easily have taken another day, but I suppose if I had been another day there would have been dozens of people looking for me. When I arrived here those handkerchiefs you sent me were waiting here. Thank you very much indeed, Girlie. It was good of you to send them and they are very much appreciated, I can assure you. Say, wasn't it rotten having to say goodbye so soon. But thanks to Mona we had a good part of the time together without chaperones. It was bosker seeing you again dear, if only for a

few hours. I hope your father wasn't angry about your coming to the station. By the way, I was lucky coming down, I managed to score a sleeping berth, so that was quite alright.

So you liked my young brother. It was bosker seeing him once again. Poor kid, he wants to get back home as soon as he can. We are going from Avonmouth (near Bristol I think) instead of L'pool. And the boat hasn't been cancelled or postponed yet. Yesterday when I arrived in London I went and said goodbye to a few cousins, only saw them for a few minutes – and then away again.

Say Kiddie, I don't know how to thank you for being so kind to me since I went to Mt. Lodge. I can honestly say that they have been my best leaves. Don't you worry that I shall ever forget you, dear, for that is absolutely impossible.

Well dear little Wee 'un, I hope to hear from you a couple of times before I go, and very often after I get home. Thank you again for those handkerchiefs.
Au revoir, with the best of love and kisses from
Your Aussie pal,
Les

Les travelled home on SS *Kermala*, via Gibraltar and Port Said from where he sent letters. He also wrote once he arrived home.

Blenheim
Gerard Street
Sydney
2nd March 1919

My Dear little Norah,
Yesterday I received your letter dated 5th January and I can assure you, Kiddie, I have been waiting for one from you; it seemed ages since I received that last one in Warminster. Well, I have been home just over a week. Arrived here 22nd of February. It was a beautiful Aussie day and when we disembarked we were put in motors and taken to the Gardens to the Anzac Buffet where there were hundreds of people waiting.

The Mater and brother and about fifty relations and friends there to collect me and then we hopped into some cars and the whole mob came along here where things went swimmingly till late at night. Gee, it was great being home again. I haven't finished visiting relations and friends. I have been going all the time.

But one thing, I have found time nearly every day for a swim or a surf, just what I have been longing for. The Heads have a deal of wind up re the 'flu. Up till yesterday everyone had to wear masks and theatres and pictures have been closed, but they are opening up now again.

He continues on 26 July, 1919:

Dancing and tennis and work, that is about all I do nowadays. Had to pick between three dances last night, so naturally picked the largest one and needless to say had a good time.

Last Saturday was some day here – being Peace Day. There was a big march on and the whole city was beautifully decorated and illuminated and at night all the warships and quite a few of the merchant ships were illuminated, so all these together with fireworks displays and a chain of bonfires round the harbour, things were only middling.

Gee but I am absolutely fed up with work, it wouldn't take much to make me clear out of this stunt. It's not that I do much work it's the fact of being tied down and red tapeism. It will not be so bad when the surfing season is in full swing again. I will just about live in it all my spare time. Well Kiddie, news is about finished so I'll imshie

Remember me to all at home. Love from

Yours as ever

Les

The Torrance home, Mount Lodge, showing the conservatory recalled by Les.

Then there is a long gap until Norah must have written to him in 1930.

211 Pitt Street
(Corner Rowe and Pitt Streets)
Sydney
12th November 1930

Dear Wee 'un,

Good Lord! What a pleasant surprise. That was a very brainy idea of yours and very lucky also as there happens to be a chap in the P.O. who knew me years ago and also my present address.

You know Norah old dear, you gave me a few surprises in your letter. You know I was only a kid when I came over your side of the world. That was when you were so good to me and altho' I would have liked to have said things to you … I didn't know what I would be doing when I arrived home, so I had to be very silent.

Anyway that doesn't affect the memories I have of dear old Mount Lodge and you and our happy times. As you say, Mona was a delightful chaperone. She might easily have spoiled the armchair and the seat in the conservatory. She was a sport. All your family must miss Mount Lodge. It was a fine house wasn't it? I just have to shut my eyes and I can see all the nooks etc where you and I had such happy hours and days.

I was very sorry to hear about Daisy's troubles. She was a good sort and her mother was a dear. You know it was through Daisy I spent so much time in Scotland. I was going to take my leave to Italy instead of England, so she gave me the address of her friends at Mount Lodge – and you know the rest.

I went to the Cenotaph here on Armistice Day and joined in the 'Silence' and believe me my thoughts were mostly of all you good people over there who were so splendid to us poor chaps from the other side of the world, and dear old Scotland will always have the place next to Australia – and one little Scottish girl in particular

So Cheerio Wee 'un,
Yours affectionately,
Les
Don't forget my address please!

Les set up a photographer's business in Sydney. In August 1938, when Norah and her family were on holiday in Gullane, Les and his wife came to visit. By this time he was a successful photographer. Dorothy was thirteen and remembers this visit well. They said she had a sweet face, 'But she's not nearly as pretty as you were, Norah,' added Les.

Norah's letters tell stories of loved ones lost, of injuries and hardships, but also of shared pleasures and fun. These shared memories were what kept many going throughout the war years when people often felt alone and frightened. Letters bridged the gap of time and distance.

CHAPTER 6

SOME CASUALTIES & SURVIVORS

The photographs, documents and other memorabilia that families store away with loving care are very often forgotten and lost as memories fade and disappear over subsequent generations. It is very fortunate that in Portobello there still exist members of a generation who have no direct recollection of the First World War, but who value the part played by members of their family and have held on to the 'bits and pieces' and the memories. We are glad that we have been allowed to share them.

In May 1992, Portobello History Society carried out a series of recorded interviews with Mrs Isa Deans, then aged eighty-seven, which ranged over her childhood, her working life and marriage. The interviewer asked only one question about the First World War, something he now regrets, but Isa's answer enabled the story of her father's exploits to be pieced together from the pages of the *Edinburgh Citizen & Portobello Advertiser*.

Isa Deans
(Formerly Isa Robertson)

'I was born at 50 Pipe Street, Portobello in 1905 – on 15 June.'

The First World War

Do you remember when your Dad went away?
Ah can picture it to this day. He was standin' there with his roll puttees an' that and Agnes was just about two and ma mother wis holding her; ma father had his arms round ma mother's neck and ah was away in a corner wi' this yellow tortoiseshell cat we had. Nobody was paying the slightest bit attention to me, till ma mother looked over an' she says, 'Tom, the other wee one's over there, you know', so he brought me over an' ah mind him cuddling us before he went away.

My father got the DCM an' Military Medal in that First World War because the first time – the DCM – he brought his captain in wounded and he was alive when he brought him in and I'll give you this and you can use it if you like – Mr Buchan, in the pottery, used to go on the Sunday mornings to the Post Office to get his mail and this

Sunday ma mother had just got out her bed when he came running up our steps and he knocked on the door and he says, 'Janet, Tam's been recommended for the VC'. So, he had been recommended, but his Captain died so he got the DCM for that and then he got his Military Medal too.

[Isabella Paton Deans (maiden surname Robertson) died on 23 June 2000, at No. 81 Liberton Brae, Edinburgh, EH16 6LE, aged ninety-five years.]

Isa's father, Thomas Robertson, had been working at Buchan's Potteries for around twenty years and had also served in the two South African Wars as a volunteer with the 'Queen's Edinburgh' Service Companies attached to the 1st Royal Scots. He re-enlisted on the outbreak of war, and was posted to the 11th Battalion Royal Scots and had been steadily promoted to the position of Company Sergeant Major. The citation for CSM Robertson's Distinguished Conduct Medal reads:

1334 CSM T. Robertson
For conspicuous gallantry during operations. Hearing cries, he at once went out and brought in from about 60 yards in front of the enemy's parapet a wounded serjeant (sic) of another regiment. Later he went out again in search of a wounded officer. (26.9.16)

The Distinguished Conduct Medal (DCM) was instituted in December 1854, during the Crimean War, to recognise acts of gallantry by ranks other than officers. It was ranked one step below the Victoria Cross and to preserve its status, most acts of gallantry from spring 1916 were rewarded by the newly instituted Military Medal. Awards of the Distinguished Conduct Medal were kept for acts of exceptional gallantry.

The citation broadly confirms Isa's recollection of events, as does a letter sent by Thomas to his wife quoted in the local paper on 22 September:

I have good news for you. I have done something great – at least that's what my Colonel thinks: and I believe I am recommended again – for what honour I could not say. I will tell you all about it. It was something like the last: but the shells were flying all over me when I went out. I had to go about 400 yards. I brought a sergeant in who was badly wounded: and then I went out again and assisted an officer who was badly wounded. That was about 11.30 at night.

On 29 September, the same newspaper reported that CSM Robertson had been badly wounded while leading his men and was now in hospital in Sheffield. A bone in his right leg had been shattered, but he had been successfully operated on to repair this and remove bullets from the leg. A year previously, he had been sent home on leave to complete his recovery from the effects of exposure to poison gas deployed by the British Army at the Battle of Loos in September 1915. Then he was able to spend ten days with his family at their home in Pipe Street, to where he returned safely at the end of the war.

It should be mentioned here that at the beginning of August Samuel Buchan, the owner of Buchan's Pottery, who had run up the stairs to tell Janet Robertson the news about her husband's honour, had received word that his son had died from wounds in France on 30 July. 2nd Lieutenant Leslie Alexander Buchan, Royal Field Artillery, was aged twenty-three and had come in to help manage the business shortly before the war began. His grave is in Abbeville Communal Cemetery on the Somme.

Many of those from Portobello serving with the armed forces received awards for gallantry or meritorious service, and it was thought to be invidious to pick out any for special mention; with one exception. This was the first war in which women played a part with nursing, so the exception is Henrietta 'Hetty' Innes of Aitchison Place. In January 1917, the government announced the establishment of a new service, the Women's Auxiliary Army Corps (WAAC) with the intention that the members would serve as clerks, telephonists, cooks and in other 'soft jobs' being done by men. By taking over these roles soldiers would be released for the front. Women in the WAAC were not given full military status and were divided into Officials (Officers), Forewomen (Sergeants), Assistant Forewomen (Corporals) and Workers (Privates). Hetty, who had been a bookkeeper at Dobbie's nurseries, Portobello Road, before she enrolled, was one of the first Scottish WAACs to serve overseas, eventually being promoted to Forewoman. In June 1918, she was mentioned in dispatches by Sir Douglas Haig for splendid work and devotion to duty. There were 6,000 members of the WAAC serving in France and, although not serving on the front line, their bases and camps were subject to shelling and bombing. Nine WAACs were killed in an attack at Etaples Camp near Boulogne in April 1918.

Above left: Joseph's locket.

Above right: Catherine's locket.

Joseph Brown's grave in Portobello cemetery.

Joseph Brown was a native of Bristol and a Corporal in the Royal Field Artillery, based at Piershill Barracks, when he met Portobello girl, Catherine Williamson, from King's Road. They fell in love and decided to get married in 1915, but the wedding did not take place in Portobello. Catherine travelled all the way down to Bristol for the wedding, which took place on 13 November 1915, in Emmanuel parish church. She came back to Portobello, but had to go back down to Bristol two and a half years later as Joseph was in hospital in a critical condition. He died on 24 May 1918, with the cause of death being given as 'died of wounds'. Joseph Brown does not appear to have served overseas, and the circumstances in which the wounds were received are not known.

Catherine brought her late husband's body back to Portobello with the intention of having the burial in St Mark's churchyard but was refused permission, so Joseph Brown is buried in Portobello Cemetery on Milton Road. His resting place is under the care of the Commonwealth War Graves Commission whose casualty details show that he had been awarded the Meritorious Service Medal. During 1916–19, Army Non-Commissioned Officers could be awarded this medal immediately for meritorious service in the field. They could also be awarded the medal for acts of non-combat gallantry and this would seem to have been the case with Joseph Brown.

Catherine's daughter from her second marriage, Mrs Irene Thomson, remembers being taken as a girl to visit Joseph Brown's grave, 'We were just told that this was where Uncle Joe was buried, and that was enough for us. I don't think we ever asked

any questions about who he was. Everyone just referred to him as Uncle Joe. I must have been well into my teens before I got to know that he was my mother's first husband. It would have been then that she first showed me the lockets with the photos of the two of them.'

Joseph Brown's name is on the war memorial in St Mark's Episcopal church.

William Tranter from Wellington, Shropshire, came to Portobello as a soldier around 1902 or 1903 with the 17th Lancers, who were stationed at Piershill Barracks. They used to exercise their horses on Portobello beach and went down King's Road to reach the sand. Catherine Marshall, who lived on King's Road, often stood to watch the soldiers and horses going by and William was attracted by her striking red hair. According to his two surviving daughters, William used to shout, 'Hi copper knob' as he went by. This must not have offended Catherine too much as she and William were married on 4 April 1904. Shortly afterwards, William left the Army and got a job as a boilermaker in a Newcastle shipbuilding yard and their first child, Jessie, was born in Jesmond, Newcastle, in February 1907. Three more children were born before the start of the First World War, after they had moved back to Portobello: Harry in February 1910, James in December 1911, and Doris in July 1914. William registered Doris' birth on 3 August, the day before Britain declared war on Germany. She was just three weeks old.

He enlisted again on 4 September and rather oddly answered No to the question on the Attestation Form asking whether or not he had previously served in any of the British armed forces. He did specify that he wished to be sent to a cavalry unit and in due course was posted to the 2nd Dragoons (Royal Scots Greys) in France. He sent a greetings card, postmarked 24 December 1914, from No. 1 Cavalry Detail, Rouen 21:

> My Dear Wife,
> Just a line to let you know that I am still here & am still doing well. I dropped Mrs Rutherford & Bella a line a week ago & I sent you a letter. I hope you received them alright. Expect to be here over Xmas so I might get a letter from you first. Hope you are keeping well, also the bairns. I will close. Yours affectionately Bill xxxxxxx

William Tranter's Army records survived the Second World War German bombing that destroyed so many First World War documents, so we are able to validate and add detail to the family story. It was known that because of the huge losses and damage to British shipping, William had been recalled from France to work for a time in his former trade as a boilermaker in Leith. The family believed that he returned to Britain early in 1916, but his records show that he reported to the sick bay on board SS *Valdivia*, en route from Boulogne to England on 10 February 1915 with toothache. There is a gap until 1 April 1915, before he was posted to the 5th Reserve Cavalry Regiment, a training regiment based at York, and it was almost a year later, on 5 January 1916, that he was attached to the shipbuilding division of Armstrong Whitworth & Co. Ltd. He was then placed on the strength of the Scottish Cavalry Depot in Dunbar, but would have been living with his family in Portobello to go to work in Leith. He was at home to register the birth of his final child, Kitty, in December 1916.

William Tranter's Christmas Card, 1914.

In 1917, he had to re-enlist at the end of his engagement and was posted to the 3rd Dragoon Guards in France in August of that year. He was promoted to Lance Corporal, but was killed in action on 24 March 1918, during the hectic, and often chaotic, first few days of the German Spring Offensive. The High Command was throwing everything and everyone into the line to try to stem the German advance, and units such the Dragoon Guards were fighting alongside the infantry as dismounted cavalry. This is something that still rankles with Doris and Kitty, William Tranter's surviving daughters, and they always say, 'If they hadn't taken away their horses then he might not have been killed' whenever they talk about the death of their father.

Catherine Tranter had received a field postcard dated 23 March saying he was quite well, and a letter would follow at first opportunity. Of course, no letter came and she heard nothing about what had happened to her husband. On 30 April, she wrote to the Cavalry Records Office at Canterbury asking for information. At the end of May, Catherine was sent a copy of a letter from the chaplain at the Casualty Clearing Station to which William had been taken that confirmed what she must have been dreading.

William's name is on the family memorial stone in the churchyard and also the war memorial inside St Mark's church.

The Thiepval Memorial to the Missing of the Somme is the largest British war memorial in the world. It was designed by Sir Edwin Lutyens and inaugurated by the Prince of Wales (later King Edward VIII) on 1 August 1932. One of the internal surfaces has this inscription:

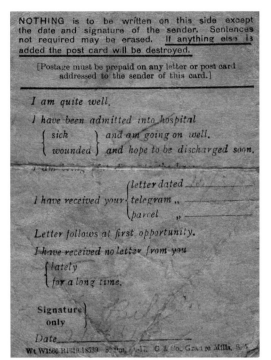

NOTHING is to be written on this side except the date and signature of the sender. Sentences not required may be erased. If anything else is added the post card will be destroyed.

[Postage must be prepaid on any letter or post card addressed to the sender of this card.]

I am quite well.

I have been admitted into hospital

{ sick } and am going on well.
{ wounded } and hope to be discharged soon.

I have received your { letter dated _____
{ telegram „ _____
{ parcel „ _____

Letter follows at first opportunity.

I have received no letter from you
{ lately
{ for a long time.

Signature }
only }

Date _____

Wt. W1566 R1610-18539 80 Pm 1-17. C & Co. Grange Mills, S

Left: Field postcard.

Below: The letter confirming William Tranter's death.

46 C.C.S.,B.E.F.
26th. May, 1918.

Dear Sir,

In reply to your letter of the 16th.inst. received by me this morning, I beg to inform you that Cpl.W.H.Tranter was admitted to this Hospital in an unconscious condition on March 24th. suffering from multiple shell wounds. He received immediate attention From the Surgeons and Nurses, but his condition did not permit of much being done for him. He passed away quite peacefully shortly afterwards without having regained consciousness.
I laid his body to rest in the British Military Cemetery at Noynn. Had I been able to obtain his home address I should have written to Mrs. Tranter soon after. Please convey to her an expression of my deepest sympathy.

Yours Sincerely,

George H. Peskett.

Chaplain.

William Tranter's grave in Noyon Cemetery.

Here are recorded names of officers and men of the British Armies who fell on the Somme battlefields between July 1915 and March 1918 but to whom the fortune of war denied the known and honoured burial given to their comrades in death.

Among the 72,191 names recorded on the memorial is that of George Lindsay, a Private in the 2nd Battalion King's Own Scottish Borderers, who had been killed on 13 September 1916 during the first Battle of the Somme. He had been a coal miner before joining the Army and was the son of Robert Lindsay, a housepainter, and his wife, Jessie, and there were ten brothers and sisters at home in Pipe Street. The official notice of death, letter of condolence and the photograph are kept by George Lindsay's great-niece, Mrs Rhona Brown, who believes that the soldier on the left is George Lindsay, as the one on the right is wearing a kilt, which is not part of the uniform of the KOSB.

John Watson was a clerk in the office of Douglas and Smart, House Agents, in Portobello before he attested on 9 June 1915. He married Jane Angus on 24 May 1918, while he was serving at Athlone in Ireland, and later that year was posted to Salonika. Britain had sent troops there in 1915 as part of a multinational force to aid Serbia against attack by Bulgarian and Austro-Hungarian forces, but by summer 1918 the fighting had largely died down. As a result of a great Allied offensive in September 1918, Bulgaria capitulated and Serbia was liberated. Some British troops stayed on as peace-keepers into 1919 and the smile of the soldier on the Christmas Card that John sent probably did not represent the true feelings of the soldiers. It was not combat that posed the greatest danger; it was illness.

No. E|24.54.89|1 (Accts. 4.) Effects—Form 100B.

Certificate of Death.

Certified that it appears from the records of this Office that

№ 6334 Private George Lindsay, 2nd Battalion King's Own Scottish Borderers,

was killed in action ~~at~~ in France

on the **third** day of **September 1916**

whilst serving with the British Expeditionary Forces.

For the Assistant Financial Secretary.

Dated at the War Office, London,

this **24th** day of **October 1916.**

(4.7.8) W17806 - 5983 10,000 2/16 HWV(2P1458/2) 6726/510
6424—140 10,000 9/16

DUDDINGSTON HOUSE,
PORTOBELLO,
MIDLOTHIAN.
22.9.16

Dear Mrs Lindsay.

I am writing to tell you how deeply grieved I was to hear of the death of your son. Short time as I knew him, I know what a dreadful loss it must be to you and equally to his comrades and the Regiment. I hope you will accept my sincerest sympathy for a loss for which the only

comfort must be your pride in him. Thank you very much for the photograph.

Yours sincerely.

E.W.S. Agar

Right: Wedding photograph of John Watson and Jane Angus.

Below: Christmas card sent in 1918 from John to Jane.

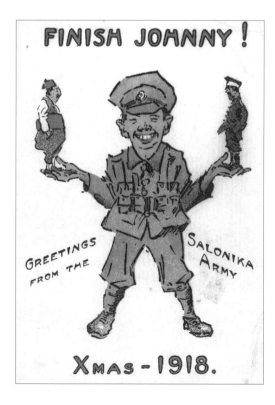

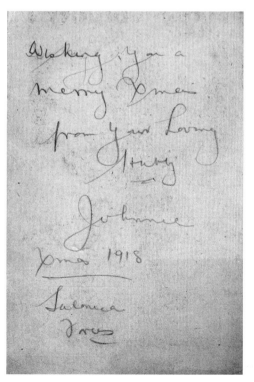

The British Salonika Force not only had to cope with extremes of temperature but also debilitating diseases. Dysentery and similar infections, but, most of all malaria, accounted for about ten times more casualties than combat did. Malaria was endemic and many men were reinfected and even after returning home some would suffer relapses for years afterwards. John Watson was finally demobilised in September, 1919, and rejoined the firm of Douglas and Smart. His daughter, now Catherine Bayes, recalls that her father was periodically unwell for a number of years when she was a girl. However, one summer something dramatic happened after the family had been on holiday to the Isle of Man. 'It was the first time we had gone there,' she said, 'but my dad noticed after we had been back for a time that his bouts of illness had more or less stopped. Of course, we went back the next year and the same thing happened, only better. He was never really bothered again, but we had quite a few more holidays on the Isle of Man, just to make sure.'

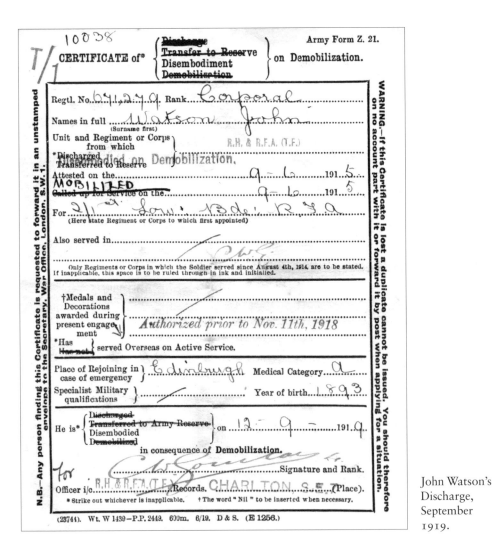

John Watson's Discharge, September 1919.

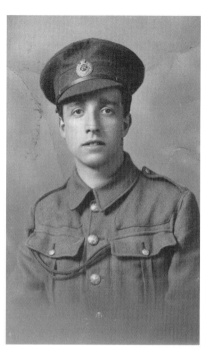

John Nelson Rodger.

George Linton Rodger could supply a photograph of his father, John Nelson Rodger, in his First World War Royal Engineers uniform, but said he did not have very many details of his service. He thought that his father had been badly injured at the Somme in 1916 and had been lucky not to lose a leg. Crucially, he did know that his service Number had been 167197 and that he was a Pioneer in Q Company of the Special Brigade, Royal Engineers. In the 1911 census, Nelson Rodger was aged sixteen, living with his parents, brothers and sister at No. 13 Wellington Street (now Marlborough Street) and described as a Dental Student. It seems that he suspended his studies to enlist, as Linton Rodger says that his father went to university after the war before qualifying as a Dental Surgeon and having his home and practice in Portobello.

The unit that Nelson Rodger joined had only recently been formed and was indeed special. On 2 April 1915, German forces launched the first poison gas attack in history, against defenceless French troops in the Ypres Salient. From that point on, any moral reservations on the part of the British disappeared. Retaliation was the order of the day and permission was given to form two Special Companies of Royal Engineers to develop and deliver poison gas. The first use of gas by the British was at the Battle of Loos in September 1915. In 1916, The Special Companies were reorganised and expanded, firstly by using volunteers from units already in France and later by postings from Britain. There were now four Battalions, each with four Companies and Q Company was part of the 4th Battalion. Members of the Brigade were under orders not to reveal the nature of the work they were involved in.

Gas was mostly delivered towards enemy troops from cylinders installed in forward trenches and the main task of the Pioneers would have been to porter them, and their

necessary lengths of pipes, up to the front, dig them in and join everything up. Members of the gas companies had to remain with the cylinders to repair couplings and links that could work loose while the gas was being discharged and fill the trenches with poisonous fumes. After they had been used they had to be unlinked, dug up and carried back again. In his book, *Chemical Soldiers, British Gas Warfare in World War 1*, Donald Richter quotes sources to the effect that what was required at the front was not chemists, but navvies, gas fitters and plumbers.

Nelson Rodger told his son that he had served with Ned Barnie. William Edward Barnie, also from Portobello and always known as Ned, is best known as a champion swimmer, and as the first Scotsman to swim the English Channel when he made the crossing in 1950, aged fifty-four. The following year, he became the first man to swim it in both directions in one season. It also meant he was the oldest person to swim the Channel, a record he held for twenty-eight years. In the First World War he was an original member of the 16th Battalion, Royal Scots, formed by Sir George McCrae, and went with the battalion to France, but in 1916 he transferred to the Special Brigade. Having studied chemistry at Edinburgh University, he was given the rank of Corporal. The *Edinburgh Citizen & Portobello Advertiser* of 4 May 1917 reported that he had been awarded the Military Medal but gave no details.

Donald Richter mentions that Q Company veterans organised a number of reunions beginning in December 1922, calling themselves Scottish Pals. Later this became Pals of Q then simply Q Club. Its final reunion was in 1977 when only three members remained.

The Gallipoli peninsula to the west of the Dardenelles Straits was the scene of the ill-fated campaign involving British and Allied forces against Turkish troops between April 1915 and January 1916. The 1/4th and 1/5th Royal Scots took part in one of the actions, the Battle of Gully Ravine, on 28/29 June, taking their objective but suffering enormous casualties in the process. The Commanding Officer of the 4th Battalion, Lt-Col. S. R. Dunn, who lived at No. 15 Durham Road, was the most notable and this extract from the unpublished diary of Private Adam Davidson Smith provides a graphic account of the circumstances:

Diary

1915
26th June.
Rise to breakfast of bacon, syrup, jam and marmalade and bread and biscuit – do not so badly. Am now expecting to go for bathe any time. Expect to go to trenches tomorrow.

27th June.
Rise this morning not very pleased at idea of going to trenches. Told that we must expect some dirty work this time.

8 p.m. Reach trenches and are placed in reserve trenches after much trouble. Hear that we are expected to take two trenches at 11 o'clock tomorrow – C. and D. Cos. To make the attack, A. Coy acting as support, B. Coy in reserve.

Thank God George is not with us this time.

28th June.

This is the morning of the great day. We are awakened at 3 a.m. and told to stand to and get any breakfast we can. At 10.45 we advance towards firing line trenches, and on arrival there we are told that C. and D. are doing splendidly. We all hop over trenches and advance 30 yds. when we are ordered to lie down. We do so and are subjected to terrible gun and maxim fire. How I am here to write this I cannot say. Friends on both sides are wounded. Dust and stones flying all around. Am hit by stones but nothing worse happens. We lie there for 15 minutes (feels like a life time) and then those of us who are able advance 120 yds to a trench where we find many of our wounded lying, some in pitiable state. We at once start and make the trench tenable, and then do what we can for the wounded, among whom was the Colonel. We now hear that we have taken 4 trenches, which we still hold. I and two others are detailed to watch over the Colonel, whom we find has been wounded through the stomach. He was really splendid, and a great stimulant to us. We carry him down about 3 p.m. to base hospital, and on our way, about 4.30, he for the first time speaks about himself and asks if he is seriously wounded. We believe it to be hope-less. We deliver him up and return to trenches about 7.30 and reach them about 9. Sleep anywhere that night, feeling very sad and tired.

29th June.

Rise this morning and look for my equipment. Find same and also find that everything of any value has been taken. Cannot blame any-body as no doubt they would think I was dead or wounded. We have done splendidly – good old 1/4th Royal Scots. Ask where our battalion is, and am told they have gone back to reserve trenches for a rest. Find them about 11.30. Am starving for a drink of tea, but same not forthcoming until 6 p.m. Sit and discuss matters. All of us feeling very sad, but very thankful to have come out of it safely.

30th June.

Am appointed Orderly for Brigade, and am kept running about. Find that we have only 6 Officers left, and about 500 men. We would not have had so many, I think, had there not been about 160 left a base ill. Am sent to headquarters 156 Brigade Rest Camp, and see they expect to be up at trenches to-night. George very pleased to see me. He has sent home P.C. telling them I am safe. Reach trenches again about 9.30 and report to Capt. Sinclair. Get to bed and kept awake by a mountain battery firing just behind me. Eventually fall asleep tired out.

Adam Davidson Smith was later commissioned as 2nd-Lt in the 4th Battalion, Royal Scots. He was killed in action in France on 2 October 1918 and is buried in the Cerisy-Gailly Military Cemetery, Somme.

Two brothers serving with the 4th Battalion, Privates Charles Henry Ford and George Turner Ford, were also killed within minutes of each other during this action. They were the sons of Mr and Mrs George Ford, No. 11 Duddingston Crescent, and former pupils of George Watson's College, Edinburgh. In July 1916, their younger brother,

Frank, who was a Corporal in the Middlesex Regiment, was seriously wounded in France, losing a leg. Another brother was a prisoner in Germany.

The Scotsman reported another account of the action that came from Private James Thomson, an ex-policeman, of Portobello, who with five other colleagues, enlisted in the Scottish Horse:

> After about a fortnight on board the transport we landed at what is a new landing-place. Our boys got a hot time of it shortly after we landed, as the Turks started firing shrapnel shells in amongst us. There were eight chaps in our company (the stretcher-bearers) wounded, and several amongst the troopers. There was one sergeant killed, and a Captain died from his wound. Sharp (another ex-policeman from Portobello) was wounded just at my side, as we were always together. He got a bullet through his thigh. He was well looked after, and was sent away in a hospital-ship. I had a narrow escape shortly after we got all the wounded attend to. Four of us made a dug-out, and put our kits round the edge of it. We had just got into it when a shrapnel burst just over us. A piece came into the dug-out. It just skiffed my head, and went into the surgical water bottle that I was carrying. The Colonel gave us all great praise for doing our work so well on the first day under fire. Our company shifted in the afternoon, and we are beside the R.A.M.C. at the clearing hospital, where all the wounded are brought. It is safe here, as the Turks don't fire on the Red Cross. Of course we see all the firing that is going on. We never think about it, and go about our work as if nothing was taking place.

Portobello does not have a community war memorial, but this has not always been the case as can be seen from this *Scotsman* report on 12 February 1917:

WAR SHRINE INAUGURATED IN EDINBURGH DISTRICT

What is thought to be the first publicly placed war shrine of prayer in the East of Scotland was dedicated on Saturday afternoon. It is placed on the outer wall of St Andrew's Home and House of Mercy, Joppa, an institution conducted by an order of sisters of the Episcopal Church in Scotland. Surmounted by the Cross, the shrine consists of a decorative panel flanked by folding leaves bearing lists of men of the neighbourhood or interested in the institution who have fallen in battle or are still serving. There are about 160 names. The centre of the panel is filled with a glazed picture of 'The Great Sacrifice' – a soldier who in the act of dying reaches out a hand to the feet of the Crucified One. There are texts and an inscription and a shelf on which flowers may be placed.

The ceremony of dedication, which included hymns, prayer, and the intoning of psalms by the company, was opened by the coming from within the grounds of the Home of a procession of clergy, sisters, and women inmates, preceded by a Boy Scout as cross-bearer, singing a hymn as they marched. The devotional portion of the simple service was conducted by the Rev. Hugh McKean, St George's Episcopal Church, Edinburgh, senior chaplain to the Church of England troops in Edinburgh district. In the course of a sort address, the Rev. George Douglas, Chaplain, K.O.S.B., said

St Andrew's Home and House of Mercy, Milton Road.

this was a service for the blessing of the shrine already made sacred by the names of the men which appear on it. The shrine would be a reminder to the people of the neighbourhood and others of the duty of prayer.

After the dedication by the Rev. Hugh McLean, (*sic*) the Mother Superior of the Home, who was attended by two Boy Scouts, placed flowers upon the memorial. The Benediction and the National Anthem sung by the company closed the proceedings.

Unfortunately, the shrine went missing when Milton Road was widened in the 1930s and the outer wall was demolished. No record of what happened to the shrine can be traced in the papers belonging to the home deposited in the National Records of Scotland. St Andrew's Home closed in the 1950s and is now the King's Manor Hotel.

There are, however, individual memorials and rolls of honour in various locations in Portobello.

St Mark's Episcopal Church, No. 287 Portobello High Street

There are fifty First World War names on the memorial and that is an astonishingly large number of deaths for a relatively small congregation. One name stands out a bit from the others and that is Richard Krause. He was born in Glasgow, but both his parents August and Christina were German and came to this country in the last decade of the nineteenth century. August was a bottle worker and brought his family to Portobello from Glasgow in the 1890s, but died in September 1900 leaving Christina to bring up their five youngest sons. Richard and his younger brother, Reinhold, became choirboys at St Mark's. All five boys had been born in Britain so would have

William Tranter memorial in churchyard.

Inset: St Mark's Episcopal church.

been liable for service in the British armed forces and Richard became a Private in the 5th/6th Cameronians (Scottish Rifles). He was killed in action in France, aged twenty-seven, on 14 September 1917, and is commemorated on the Arras war memorial. Unfortunately we know nothing about Richard before the war except that he was unmarried; two nephews still live in the Portobello area but know very little about their uncles. Like most soldiers on active service, Richard made a will in which he left everything, including £120 cash, to his mother.

Portobello Old Parish Church, Bellfield Street
The memorial from Windsor Place church was placed here when the congregations merged. The church is also home to the memorial from the defunct Portobello Working Men's Institute, but this is on the wall of a narrow corridor and could not be photographed.

St Philip's Church, Abercorn Terrace
This is housed in the Centenary Hall, which is attached to the main church building. Lt-Col. S. R. Dunn's name appears on it.

Above left: Old Parish church.

Above right: Windsor Place church.

St Philip's church.

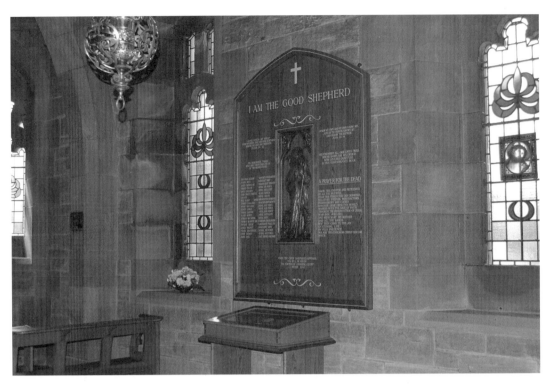

St John's Roman Catholic church.

Portobello High School.

St John's Roman Catholic Church, Brighton Place
This beautifully carved memorial commemorates the dead of the two world wars.

Portobello High School, Duddingston Road
This Roll of Honour is placed beside a notice board on the ground floor of the present school building. In its centre is a facsimile of the seals and signatures on the Treaty of London, 1839 – the original 'scrap of paper'.

Portobello Amateur Rowing Club
The memorial has no permanent home at present and is in the safekeeping of former members of the club who are looking to have it placed in one of the local churches.

 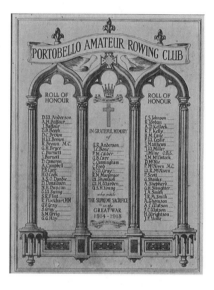

Above left: Portobello Amateur Rowing Club.

Above right: The Roll of Honour and Memorial hung in the boathouse until the old wooden building was sold in 1985. It is now in the safe-keeping of former club members, who intend to have it placed in a local church.

CHAPTER 7

ARMISTICE & AFTERMATH

Germany signed a peace treaty with the new revolutionary government of Russia in March 1918, enabling it to transfer large numbers of troops from the east and launch a massive offensive against the Allies on the Western Front on 21st of the same month. The hope was that with its numerical advantage, victory could be achieved before American forces became fully integrated into the Allied ranks. However, after initial success and gaining territory, the Germans failed to make the decisive breakthrough and the advance ground to a halt in June 1918. Having built up superiority in men and armour, it was now the turn of the Allies, and what became known as the Hundred Days Offensive began on 8 August. The German Army was forced to retreat behind the Hindenburg Line and when these defences, hitherto thought to be impregnable, were breached, the Supreme Command admitted that Germany was defeated. Power was handed to the Parliament, and Chancellor Max von Baden began peace negotiations with the Allies. After the Kaiser was forced to abdicate and flee to Holland on 9 November 1918, terms were agreed and the Armistice was signed early in the morning of Monday 11 November, stipulating that all fighting was to end at 11 a.m.

The people of Portobello got the news of the Armistice shortly after eleven o'clock from the sirens and hooters of the works followed by the tolling of the town bell to give it an 'official' status, and the streets quickly filled with cheering schoolchildren and adults wearing flags and tricolour rosettes. As the potteries had stopped work in celebration, their female workers marched in procession through the town, which, in a remarkably short time, had been decorated with flags and streamers stretched across the High Street. The bells of the town churches joined in, but the local paper noted that they did not ring out 'all at once', commenting that St Philip's 'reserved its demonstration till about four o'clock'. One person was singled out for special praise for her efforts on the day:

> It is interesting to record that a young lady, Miss Scott, in the absence of the church officer of Windsor Place Church, rang the bell and kept it tolling for twenty minutes. She was heartily congratulated for her achievement for the bell is a heavy one, and as our informant adds, it will about constitute a record. It is further proof of what ladies can do when necessity arises.

Mr J. M. Hogge MP had been roundly applauded by an audience of over 200 when he said in a speech in Portobello Town Hall, at the start of the peace negotiations, that he would not be prepared to agree to any peace that did not involve the absolute and complete defeat of Germany. On the day, though, the prevailing feeling that underlay the cheering was not of revenge but of thankfulness tinged with a measure of disbelief that at last the fighting was over. It was not yet peace but no one thought that the guns would start firing again and the fortunate ones could now look forward to their husbands, sons and boyfriends coming home for good.

Robert Fenley says that his grandfather never regarded himself as German. He always said that although the Mutzkes originated from German speaking regions such as Saxony, he and his brothers and sisters were born all over Europe. In an era when nationality and boundaries were not matters of concern, they were craftsmen who took their skills wherever they were required. They and the other bottle workers who came to Portobello were truly European.

The First World War finally brought the age of travel without passports or documentation to an end as the combatants enforced controls on their borders, and these continued after the war was over. In Britain, the powers of the original Act of 1914 that had caused the internment of the Mutzke brothers were extended and continued into peacetime by the 1919 Aliens Restriction Act. Parliament renewed the Act every year thereafter and once again a Mutzke family suffered upheaval. In 1935, Louisa and her sons came to Britain to visit relatives. Her intention was for them all to remain in this country and for her husband, Karl Heinrich, to join them, but because of the political and economic crises in Europe the authorities were imposing strict controls, and would only allow the Scottish-born sons to remain in this country. The decision was made that Walter Heinz and his mother would return to Dresden and the others would remain in Britain. During the Second World War, Walter served as a signaller in the German Army, firstly on the Russian Front and then in France where he was taken prisoner. Three of his older brothers, Willi Paul, Oswald Franz and Richard, were in the British Army, and the other brother Carl, who became an actor, played a German officer in a propaganda film.

There were changes in Portobello during and after the war. As has been mentioned elsewhere, a number of old established shops and businesses had closed due to a shortage of staff caused by men being called to the forces. Although they had by no means disappeared from the streets, horses were rapidly being replaced by motor lorries, buses and private cars. There had been debates in the local paper over the respective merits of the horse drawn cab and the new taxicab, but no amount of sentiment could halt the advance of the internal combustion engine. In August 1915, Mr J. Cormack closed down his horse-drawn cab business in Bath Street Lane, selling all four of his horses, three landaus and a twenty-eight-seater coach and he was closely followed by Mr A. Roberts, of the Baileyfield Road Stables, who also decided to sell his coaching horses. There were other sales during 1916. Melrose's Dairy, in the High Street sold off its horses and Roberts, the coal merchant, included his horses in the sale of his business in November of that year. Competition from motor transport may not have been the only factor that influenced owners whether or not to sell their horses. They would have

known that the demands of the British Army in France had created a ready market with guaranteed high prices, and who knew how long that would last? During the war, the British Remount Department spent £67.5 million on buying and transporting horses to France and sent over more tons of animal feed than ammunition.

Hopes that the lost promenade pier would be rebuilt and the Marine Gardens restored when the war ended were not realised. Although there were a number of locally inspired proposals in the interwar years to build a new pier, they were successful only in getting column inches in the newspapers and failed to persuade any individuals or organisations to invest in what would have been a very risky enterprise. When the site of the Marine Gardens pleasure park was surrendered by the military after the war, nobody emerged to try to emulate the success of the original entrepreneurs and restore the buildings to their former glory. There was a series of auction sales on the site, first of vehicles and all kinds of surplus military equipment and property followed by what was left of the buildings. Most of the land was bought by Edinburgh Corporation, but in a shrewd piece of business Fred Graham-Yooll bought the Empress Ballroom and the adjoining sports stadium. The ballroom, which doubled as Scotland's largest roller skating rink, was refurbished and when it reopened reached new heights of popularity in the dance crazy 1920s and 1930s. Customers flocked from all over Edinburgh and district, attracted by top bands such as Joe Loss, Harry Roy and Ambrose. The stadium hosted a new spectator sporting craze, motor cycle speedway, as well as soccer. George Baird recalls:

> Leith Athletic Football Club used that piece of ground at the extreme east end of the Gardens as their home ground ... it was used as Dirt Track[Speedway]. I paid several visits to the ground but soon tired of it. On the occasion of the World Championship a crowd estimated at 34,000 was present. I remember Drew McQueen [and] George McKenzie, a tubby cheery lad who had a motor-cycle shop in Dalry Road.

When the last troops had left the nearby former chocolate factory, its management was transferred to the Ministry of Labour and in 1919, it began a new life as a government training facility for disabled ex-servicemen. The large building could cater for over 400 trainees in a number of trades including construction, engineering, motor engineering, vehicle body work and tailoring. A monument to the high level of skills attained by the trainees still stands today in the shape of the nearby house, No. 72 Inchview Terrace, which was built by them. In 1923, the premises were taken over by Edinburgh Education Authority who converted what was essentially a factory into a technical school running evening classes for apprentices. Over 700 apprentices enrolled in the first session of what became the highly regarded W. M. Ramsay Technical Institute that over many years provided day and evening classes in a wide range of crafts. The Grade A listed building has now been converted into flats.

By the end of the war, electricity generating capacity in Edinburgh was even more inadequate to meet the demands for light and power than it had been in 1914. Edinburgh Corporation was only too well aware of the urgency of the situation and of its legal requirement to meet the needs of its community, which would be impossible

unless new capacity was created. Government permission to restart the construction of the generating station at King's Road was delayed while the Board of Trade decided on a future strategy for electricity supply in Britain as a whole, but the embargo on materials was at last removed in spring 1919. The Corporation quickly went ahead, revised plans drawn up in 1914, and started building a new station with three times more capacity than originally planned. The original estimated cost had been £232,600, but this had now increased to almost £1 million. The station was officially opened by King George V on 11 July 1923. In fact, this was just the first phase of a carefully planned programme that would see capacity increased to meet projected demand in two more phases over the next twenty years. The final extension to the station was completed in 1939, which was when the array of short, stubby chimneys was replaced by the famous tall one.

Frustration and anger at the increasing inefficiency and breaks in service of Edinburgh's cable car system during the war was even more intense in Portobello than in other parts of the city. The system was operated by the Edinburgh & District Tramways Company Limited whose contract was due to end in the summer of 1919, and the Corporation confirmed its intention not to renew it and instead operate the system itself. After the takeover, Mr R. S. Pilcher, the Tramways Manager, reported that during the war only minimum repairs had been carried out on cars, plant and buildings and, as the contract drew closer to its conclusion, less and less work was done. As a result, the cars were literally falling to bits. Pilcher's recommendation that on financial and operational grounds, and in the interests of customer comfort and safety, the cable system be abandoned and replaced by electric tramcars powered by overhead wires was accepted. As all routes could not be converted at the same time, the work was carried out in sections and the one from Waterloo Place to Joppa was the last to be completed on 24 June 1923. There was no celebration to mark the last cable car journey and the *Edinburgh Citizen & Portobello Advertiser* remarked that 'there is no mourning in the City at their going'. The electric tramway brought 'a great acceleration of speed, and the journey to the post office is now one of comfort and quickness'. It was now possible to travel by tram from Edinburgh to Levenhall, Musselburgh via Portobello without having to change at Joppa.

When the new Electoral Register was published in 1918, the number of persons in Portobello eligible to vote had more than doubled from 3,795 in 1914 to 8,413. Most of the increase would have been due to women registering for the first time after the terms of the Representation of the People Act passed in the summer of 1917 came into force. Now women aged thirty or over who were householders or married to a householder would be able to vote to elect a member of parliament. The age limitation would not have been popular with Mrs Marion Grieve and other veterans of the pre-war suffrage movement, but in 1928 the voting age for women was lowered to twenty-one – the same as men. Granting the franchise to women was generally seen as reward for their contribution to the war effort, although this was always denied by the government. An article of February 1917 praised in glowing terms the response being made by Musselburgh women to the crisis caused by so many men being away at the front:

with such a ready response as our townsmen gave to the call of duty it was but natural that great difficulty should be experienced in obtaining male labour. The ladies, however, rose to the occasion in splendid fashion determined to do their bit and they have certainly done so in a laudable and praiseworthy manner.

Many were doing the kind of work that would have been unthinkable before the war. Some were to be seen navvying, repairing the tram tracks, while others were delivering coal, even carrying the sacks to the top storey of tenements. Women were also carrying heavy loads delivering mail and were now employed at the railway station as booking clerks and ticket collectors, all spheres previously occupied by men. One has to wonder if those businesses in Portobello could have survived if their owners had looked at what was happening in Musselburgh and taken on women. We have no similar testimonial on behalf of the ladies of Portobello, but what is abundantly clear is that they were well to the fore working in branches of national bodies such as the Red Cross or as members of local clubs, guilds and other voluntary groups raising funds for the troops and providing care and comfort for all who needed it.

There was one group of women who found life very hard after the war; those whose husbands did not come back and were left to bring up children on their own. The weekly casualty lists show that this was a very large group by the end of the war. Jobs were hard to come by as preference was given to men discharged from the forces, and those that women did get were likely to be unskilled, monotonous and poorly paid. This is how Catherine Tranter's surviving daughters, Doris Bourne and Kitty Marshall, recorded how their mother earned the money that eked out her War Pension:

> When her husband was killed Catherine Tranter became a war widow with five children to bring up. Jessie was 11, Harry 8, Jim 6, Doris 3 and Kitty 15 months. The war pension was not much so Catherine took on work where she could. She worked as a waitress at Sharp's at the foot of Bath Street. When that closed down she did waitressing at an ice cream shop on Portobello Prom run by a family of Russian Jews named Shenkin. Her sewing machine was her prize possession. She made beautiful clothes for all the family. She would go window shopping in Jenner's in Princes Street, study the designs and then return home to make the same at a fraction of the price. She took evening classes in sewing at the Ramsay Technical College at the bottom of Portobello Road. She also took in sewing for other people, hemming curtains etc. A further source of income was to take in lodgers during the summer. The flat at 45, Tower Street [now Figgate Street] had an attic room that was used for the summer visitors.

Giving them the right to vote was indeed a significant step forward in women's slow progress towards equality of status with men, but at the time it did nothing to improve the situation in which many found themselves. To those such as Catherine Tranter struggling to provide for young families, if they had time to think about it at all, did it seem something truly empowering?